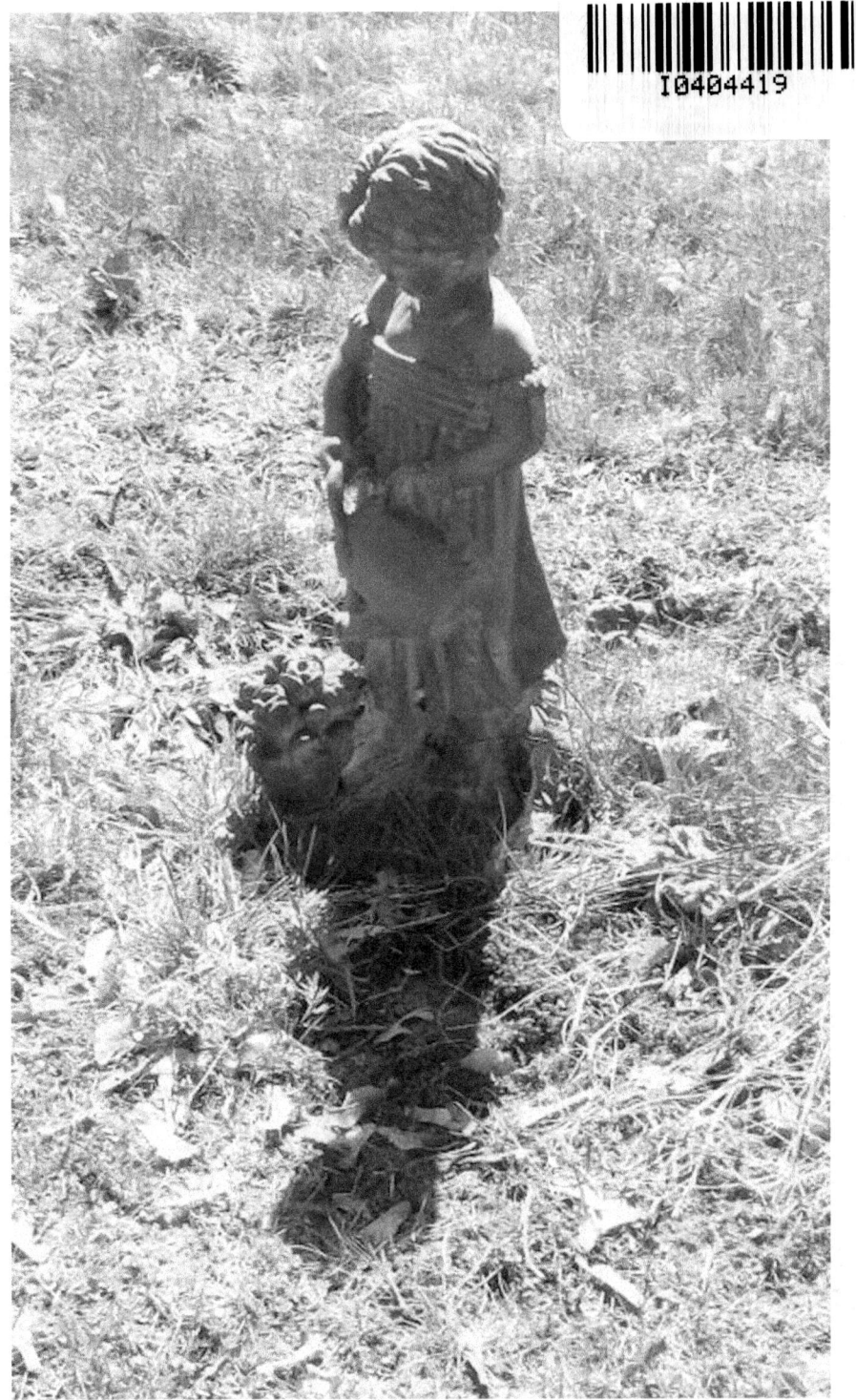
Mountain View Cemetery, Shrewsbury

The story represented in this publication is a work of fiction. Any similarities to events and persons living or otherwise is purely coincidental.

Memento Mori
2012 First Printing

c. 2012 Bret&Sydney Herholz
herbertzohl.blogspot.com

All rights reserved. With the exception of artwork being used for review purposes, no portion of this book may be reproduced without the authors' conscent.

Property of Bret&Sydney Herholz and printed in the U.S.A.

Published by Soft Shoe Press

Also by Bret M. Herholz:

Diary of the Black Widow

Confessions of a Peculiar Boy...And Other Stories

The Spaghetti Strand Murder

The Adventures of Polly and Handgraves: A Sinister Aura

Sherlock Holmes: The Painful Predicament of Alice Faulkner

Gloomy Presentiments of Things to Come by Susurrus Din

The Ninnies by Paul Magrs

12 Weeks of Summer by Joseph J. Andrade

The Casque of Amontillado

Loogar by N.E. Castle

A Study in Sherlock: 12 Years of Sherlock Holmes Inspired Artwork 2000-2012

Coming Soon

What Makes Us Human by Joshua Michael Stewart

Frankenstein A.D. 1931 by Andy Fish

Romance with a Croquet Mallet (or a Plausibly Stirring Afternoon at Slougshire Manor)

Available for purchase through Amazon.com, alternacomics.com, Obversebook.co.uk and wherever fine books are sold!

Cemeteries are not for the dead.

Sure, they're a convenient place for the dearly departed to hang out until Judgement Day, but they can be so much more for the rest of us still residing above ground.

Call them what you like ~ graveyards, boneyards, church yards or dormitories for the dead, it's all the same. Cemeteries hold moments of history, frozen in time and available to any pedestrian who wanders in off the street. Passing through those cemetery gates, a visitor can be instantly transported back centuries; nearly four hundred years here in New England.

Their art will astound you, their stories will amaze you, their messages are clear: "MEMENTO MORI". In case your Latin is rusty, the message translates to "Remember Your Mortality" ~ meant to remind the living that time was short, life was hard, so be prepared for the inescapable end to arrive at any moment. Initially a Puritanical message about saving one's immortal soul for hopeful transport to another, better place, it transcends time and is still relevant today. No one gets out alive.

If this all gets a bit too heavy, not to worry; roam through these beautiful spaces and make some new friends, while getting an art education. There are sure to be gravestones with winged skulls, crossed bones, curious faces, hourglasses, and other cleverly carved symbols. You may find someone who fell from a bridge, was murdered by his wife, ate poisonous oysters, was run over by a cart, or fell and bumped his head, (causing him to die in about 30 minutes). Hey, sometimes Death Himself, often in the guise of Father Time, even makes an appearance. You never know who you'll meet.

Each visit is an adventure, a mystery, an escape.

In 2005, The Gravestone Girls added a pen and ink drawing to their artifact collection. It is titled "Picnic in the Cemetery" and features a well dressed 19th century couple enjoying a glass of champagne amongst the headstones of an ancient burial ground. He is reclining at the feet of his femme fatale, who is gracefully perched atop an old gravestone.

The artist understood exactly how this scene should be represented ~ cemetery visitors relaxed, happy and enjoying their surroundings. That artist was Bret Herholz, and now he and his other half, Syd, expand on that with this new publication. They bring you their unique vision of images from well known burial places in Massachusetts ~ the seat of some of the best surviving gravestone art and most notable history to span the New England centuries.

Cemeteries: beautiful, educational, cool…….and best of all, free. Go now!

Memento Mori~
The Gravestone Girls
www.GravestoneGirls.com

For Susurrus Din

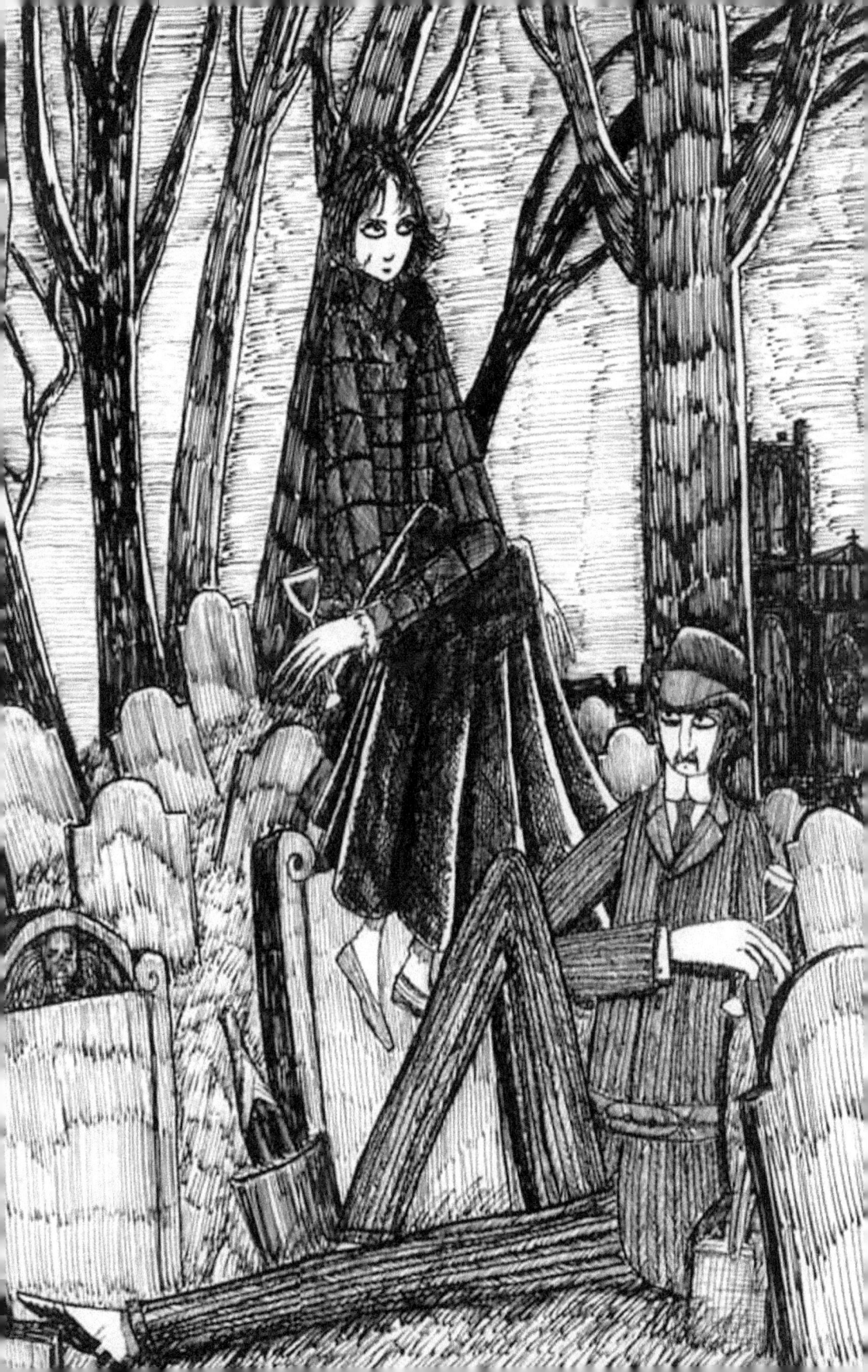

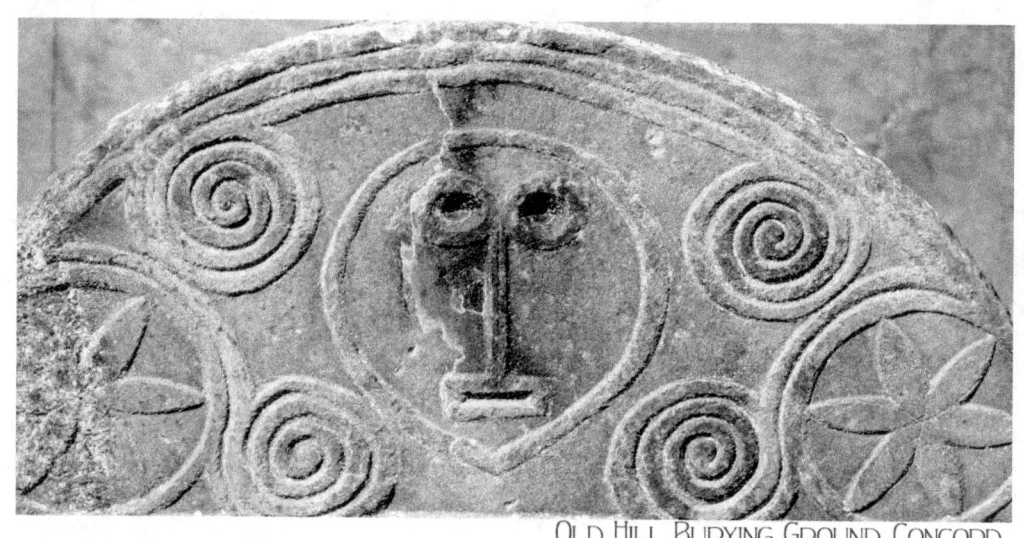

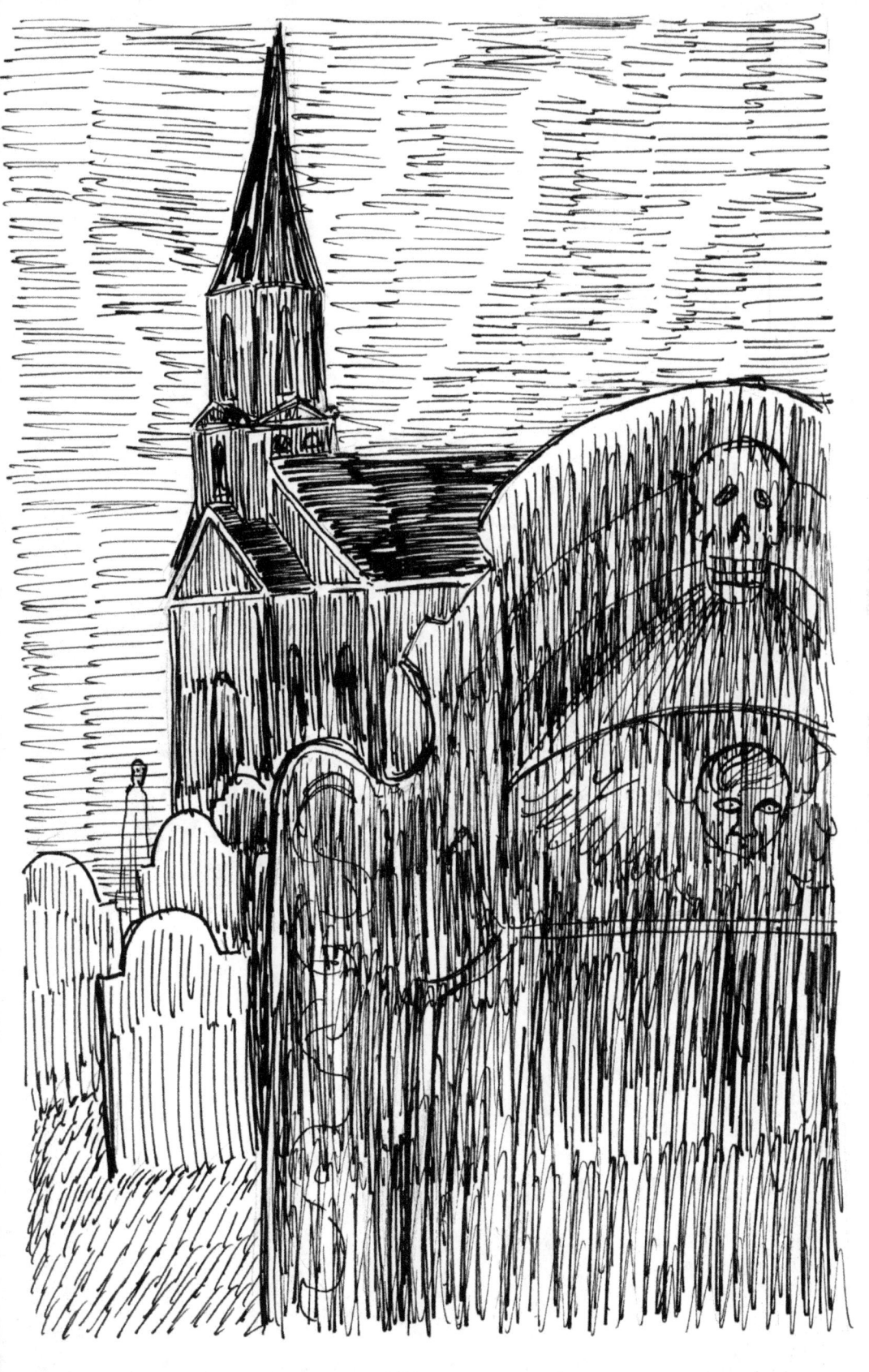

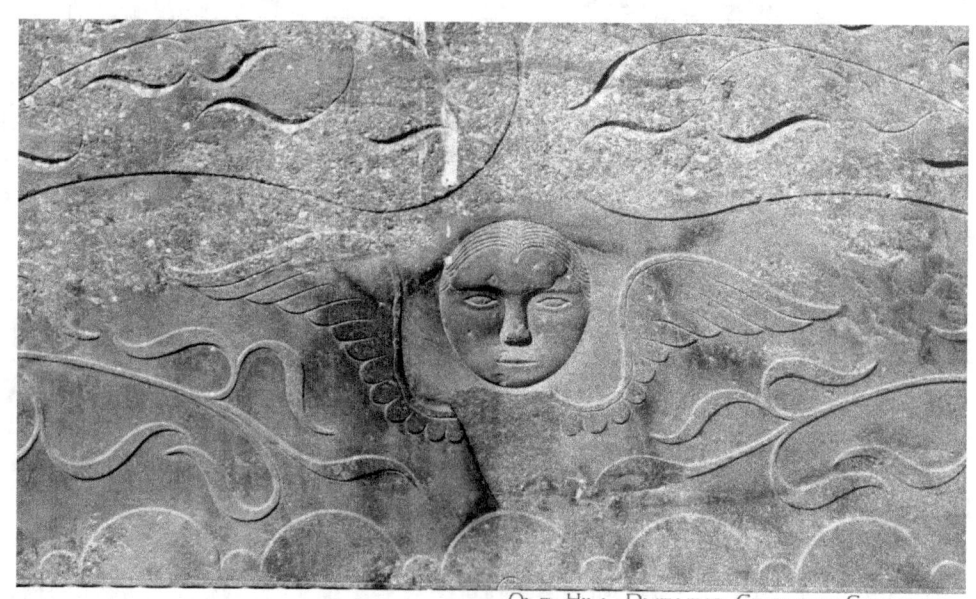
OLD HILL BURYING GROUND, CONCORD

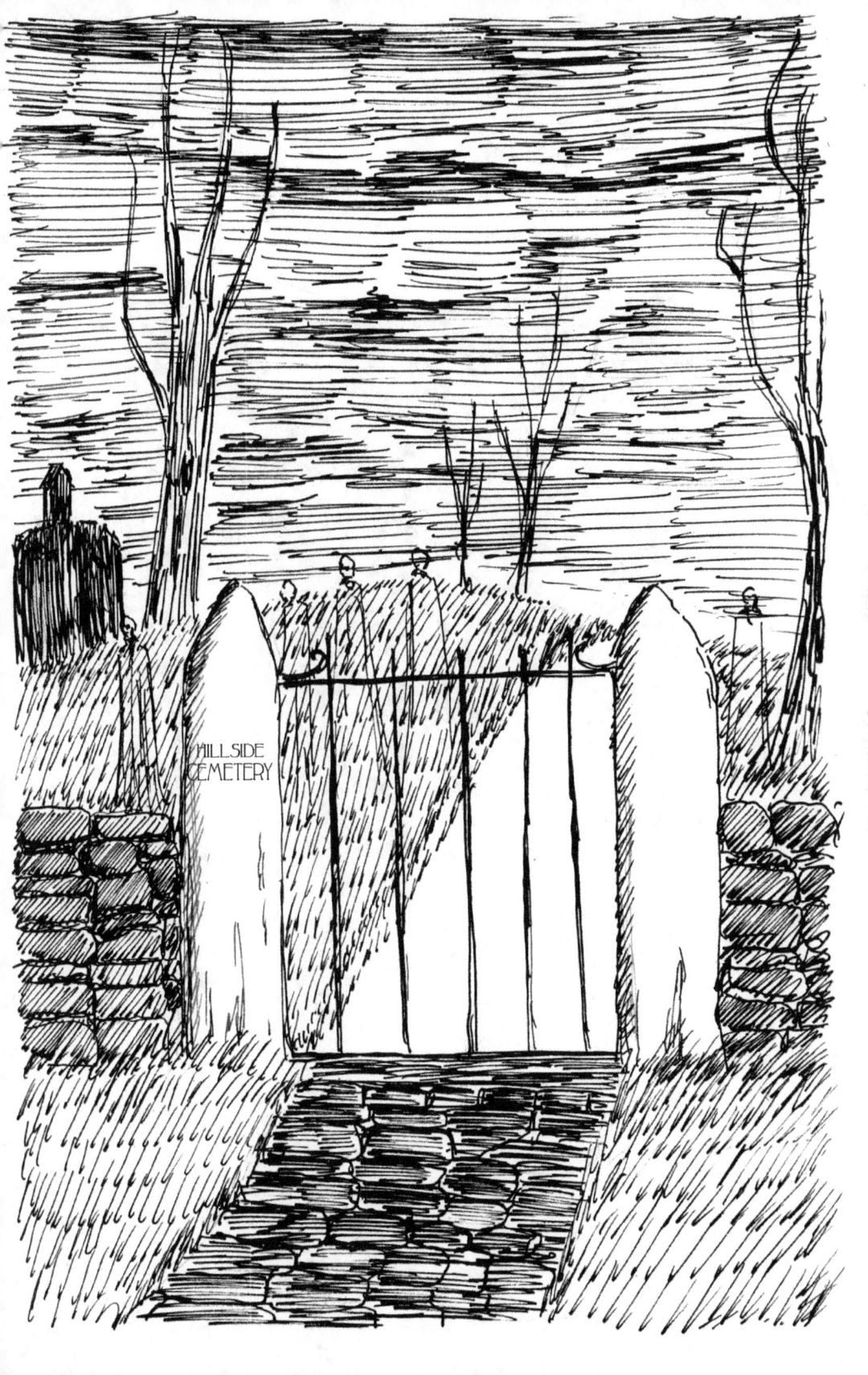

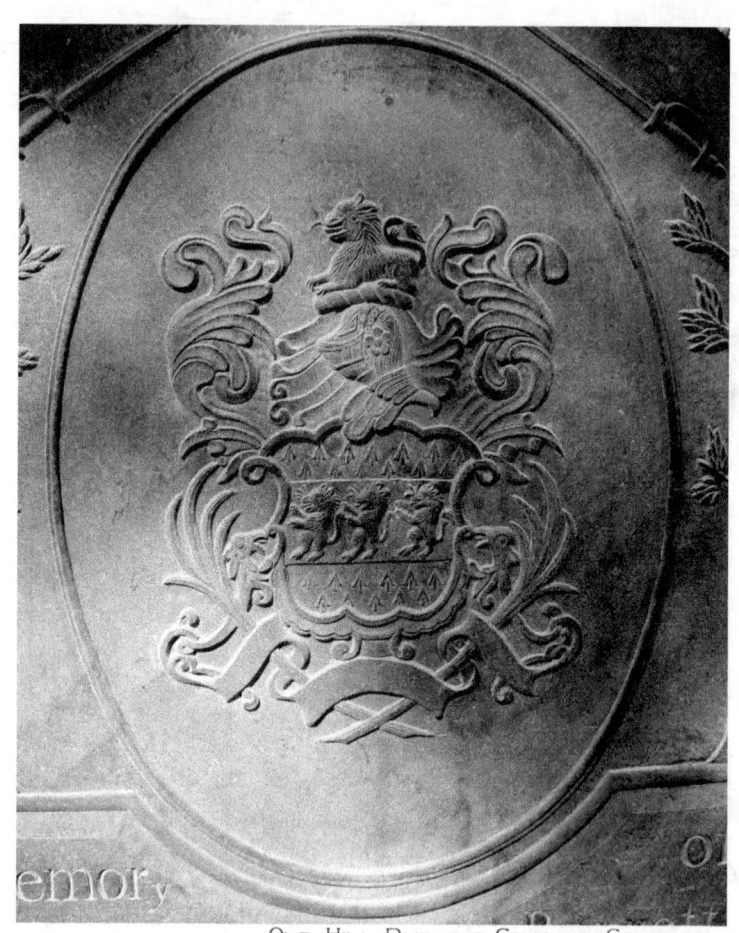
Old Hill Burying Ground, Concord

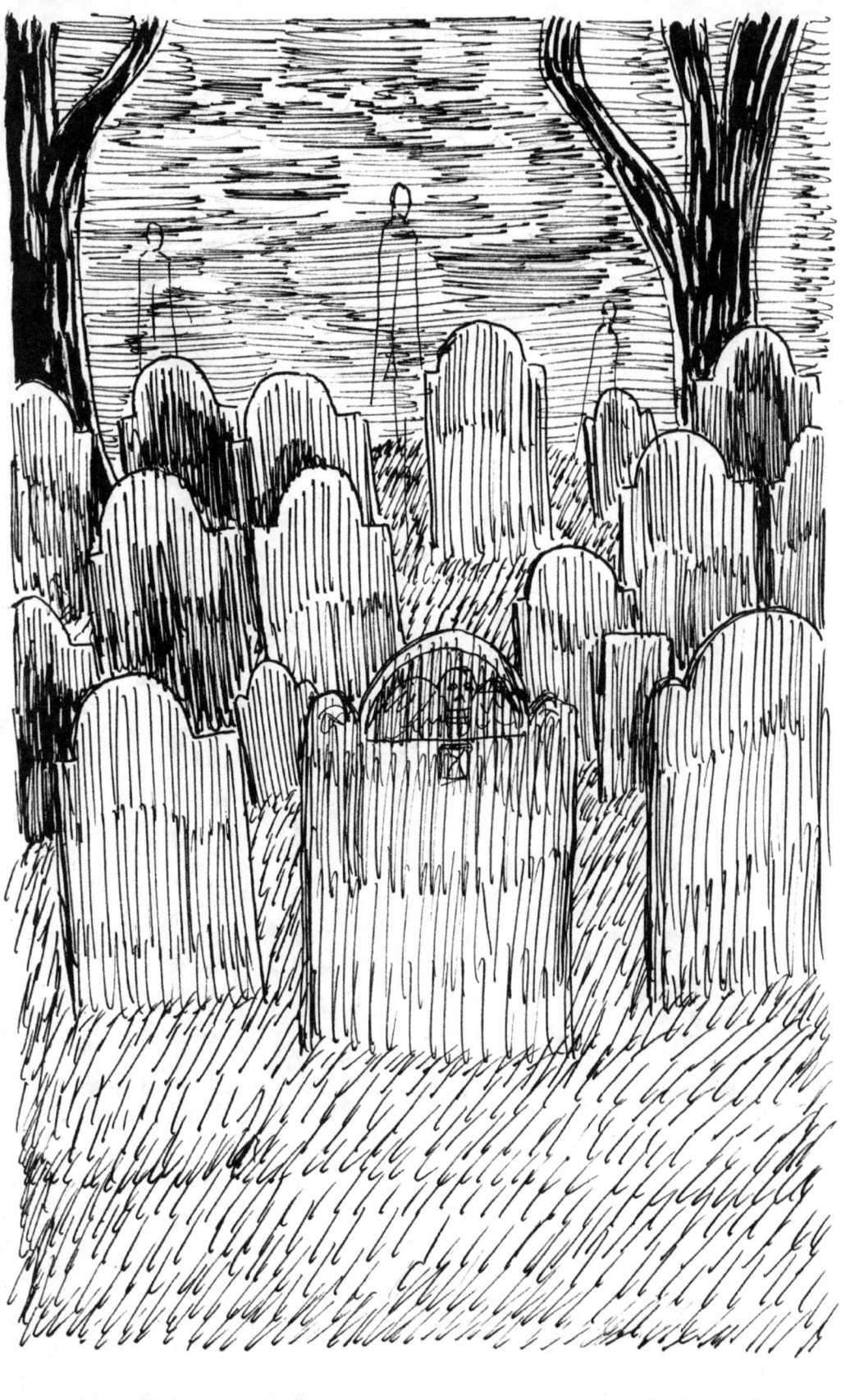

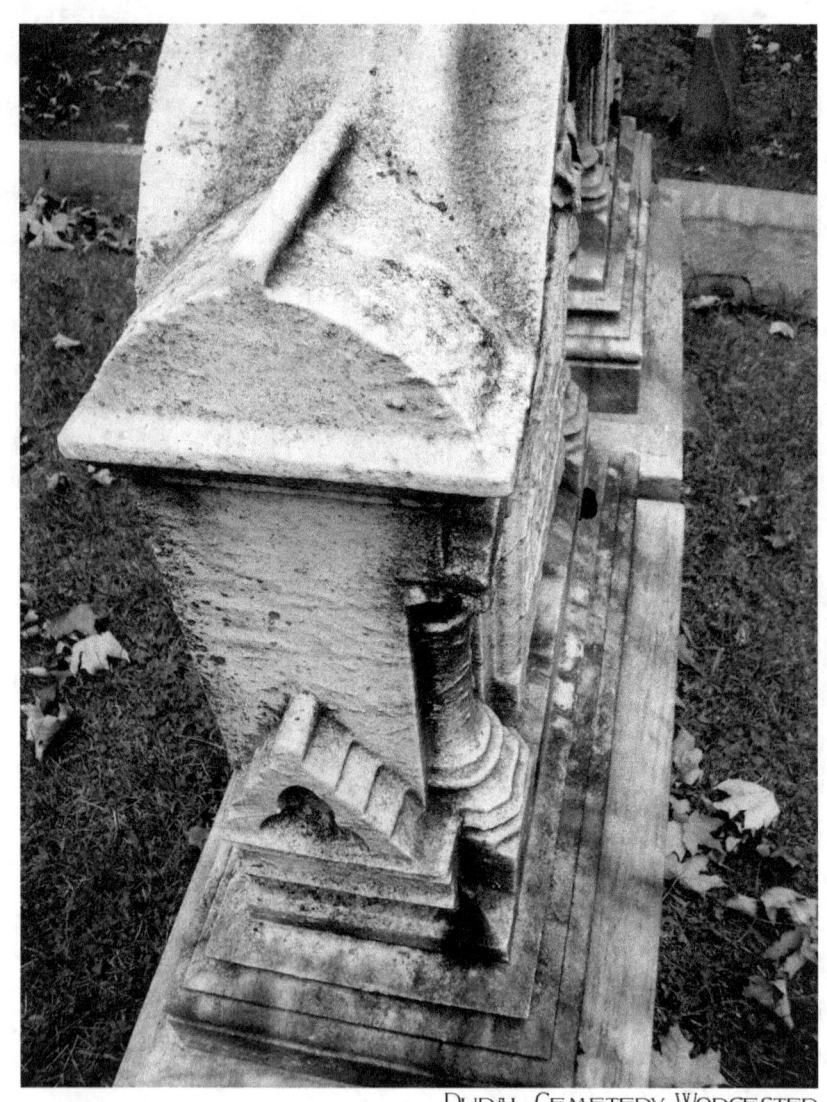

Rural Cemetery, Worcester

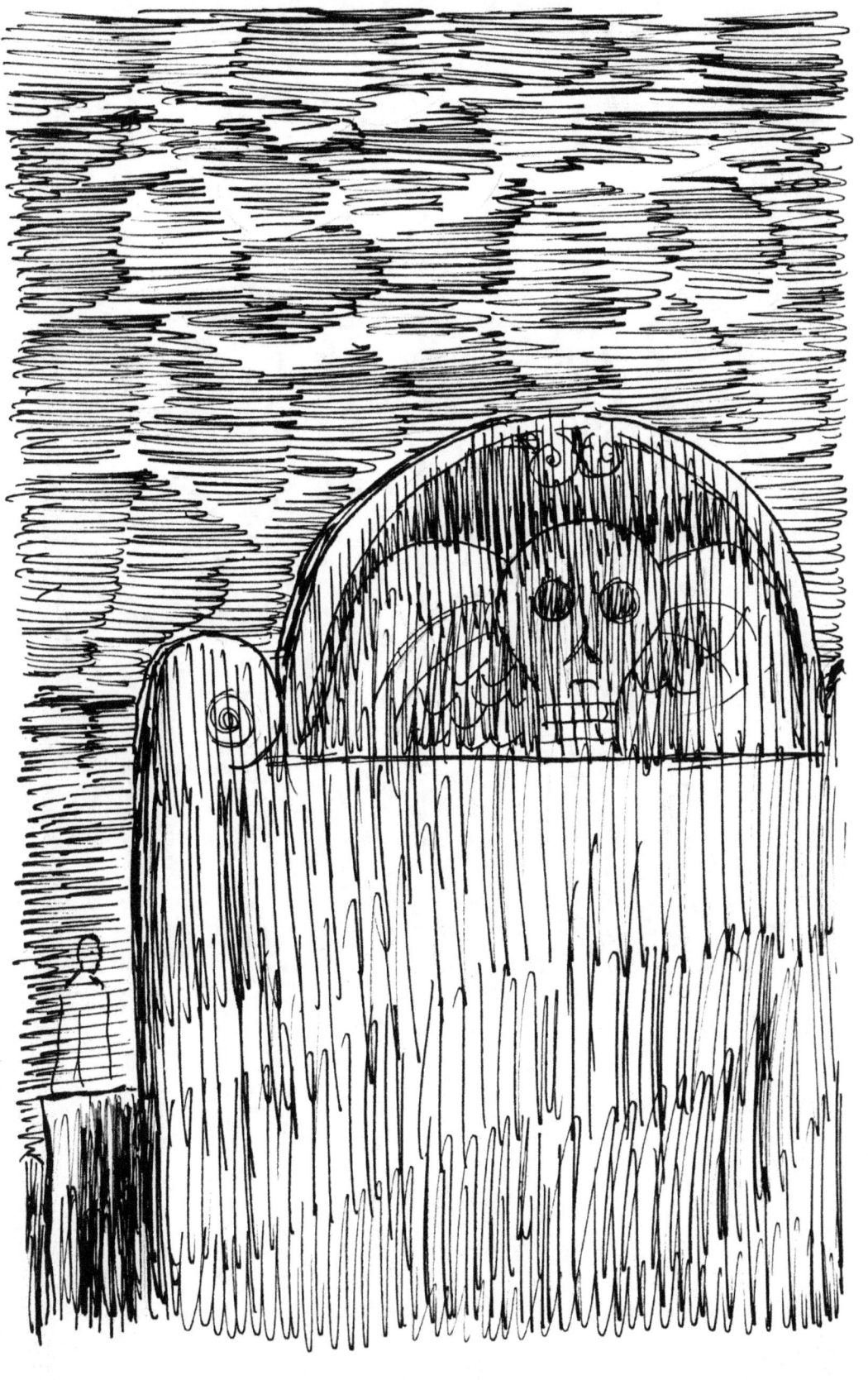

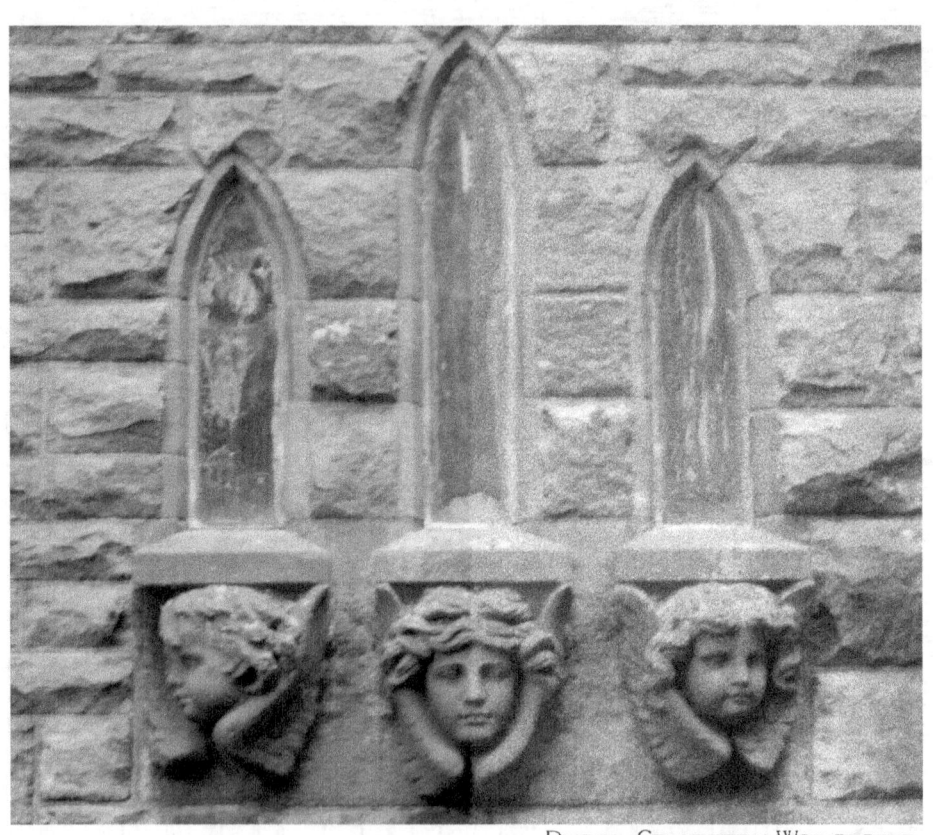
Rural Cemetery, Worcester

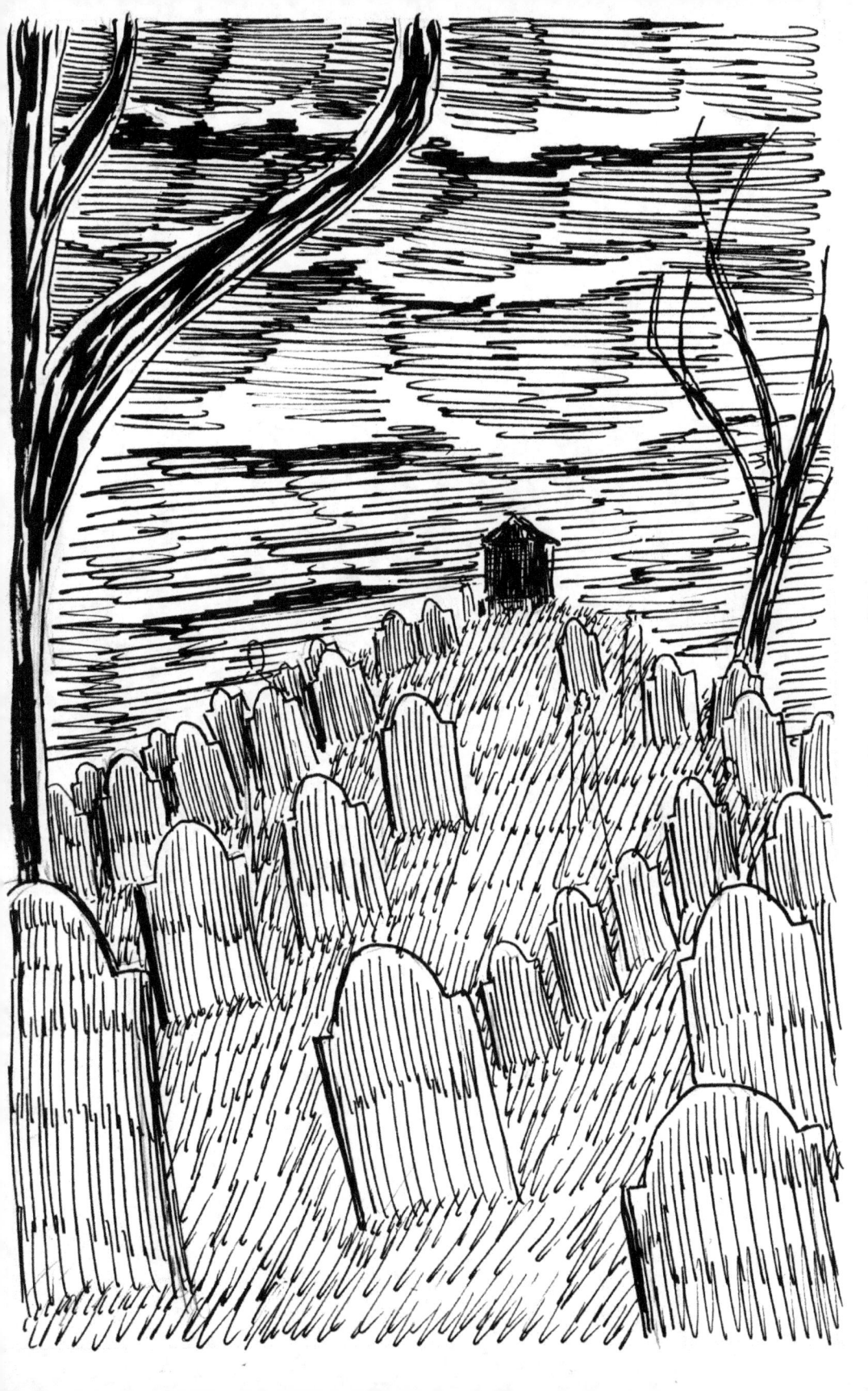

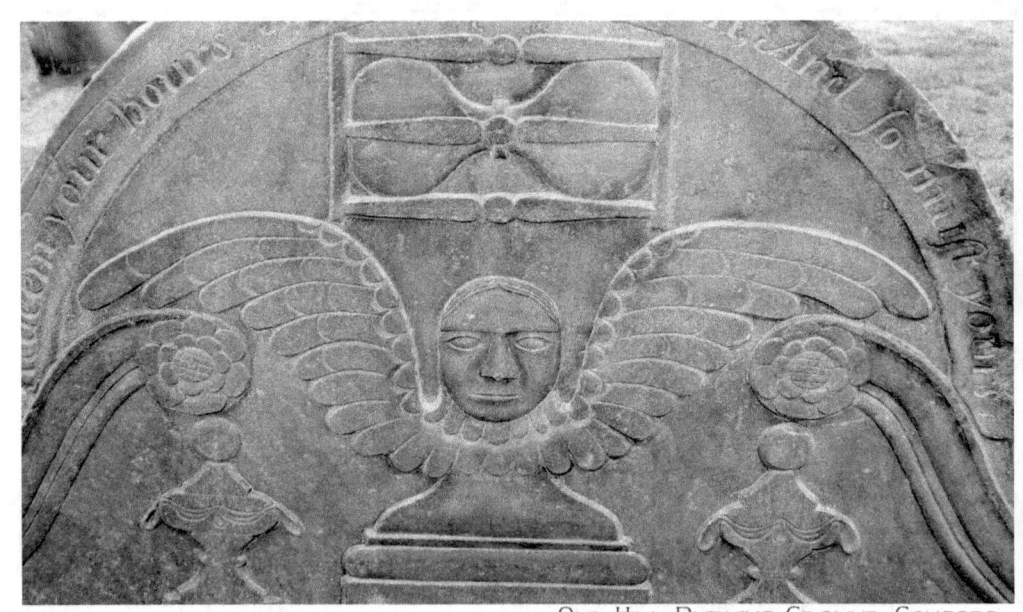
Old Hill Burying Ground, Concord

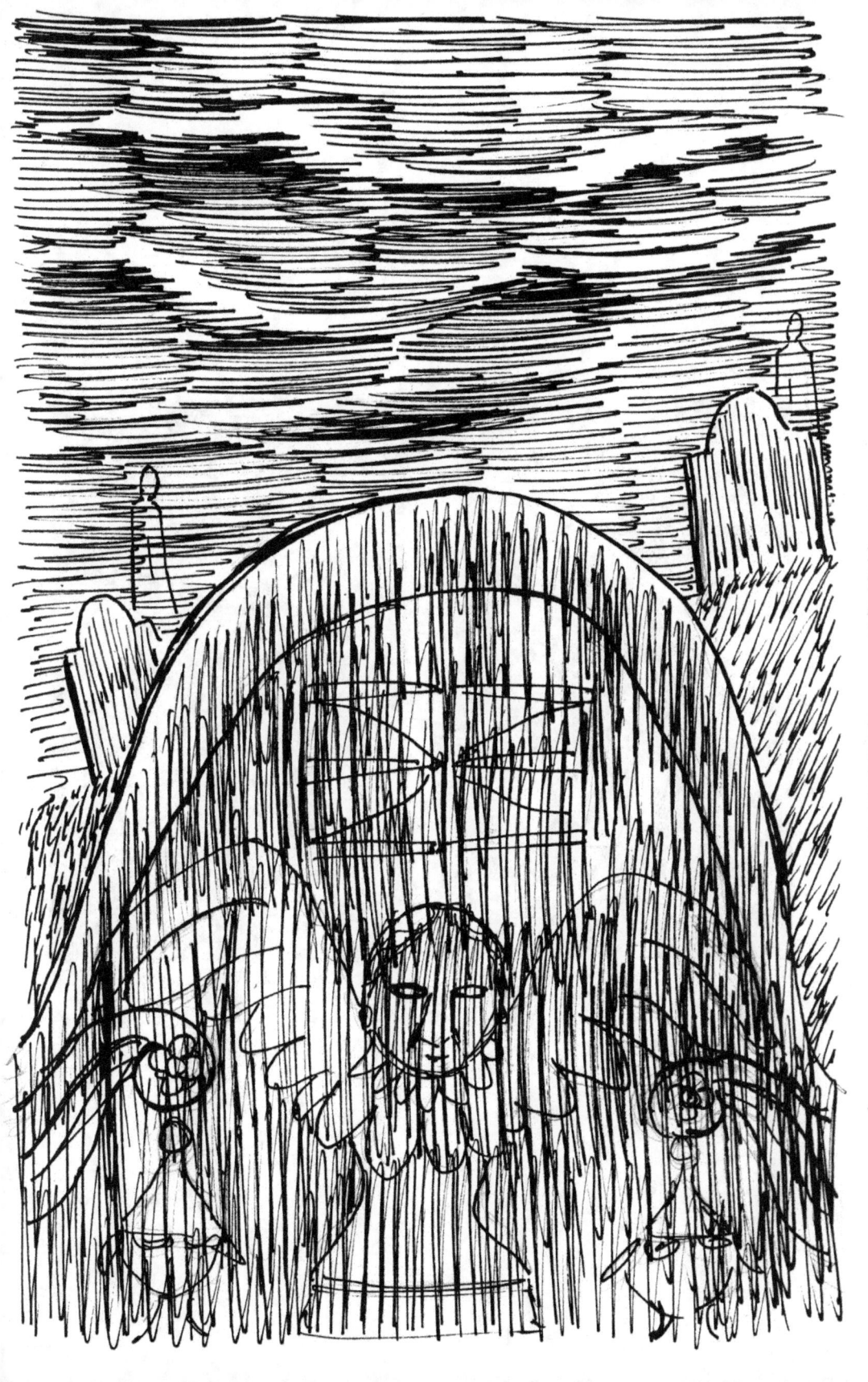

Rural Cemetery, Worcester

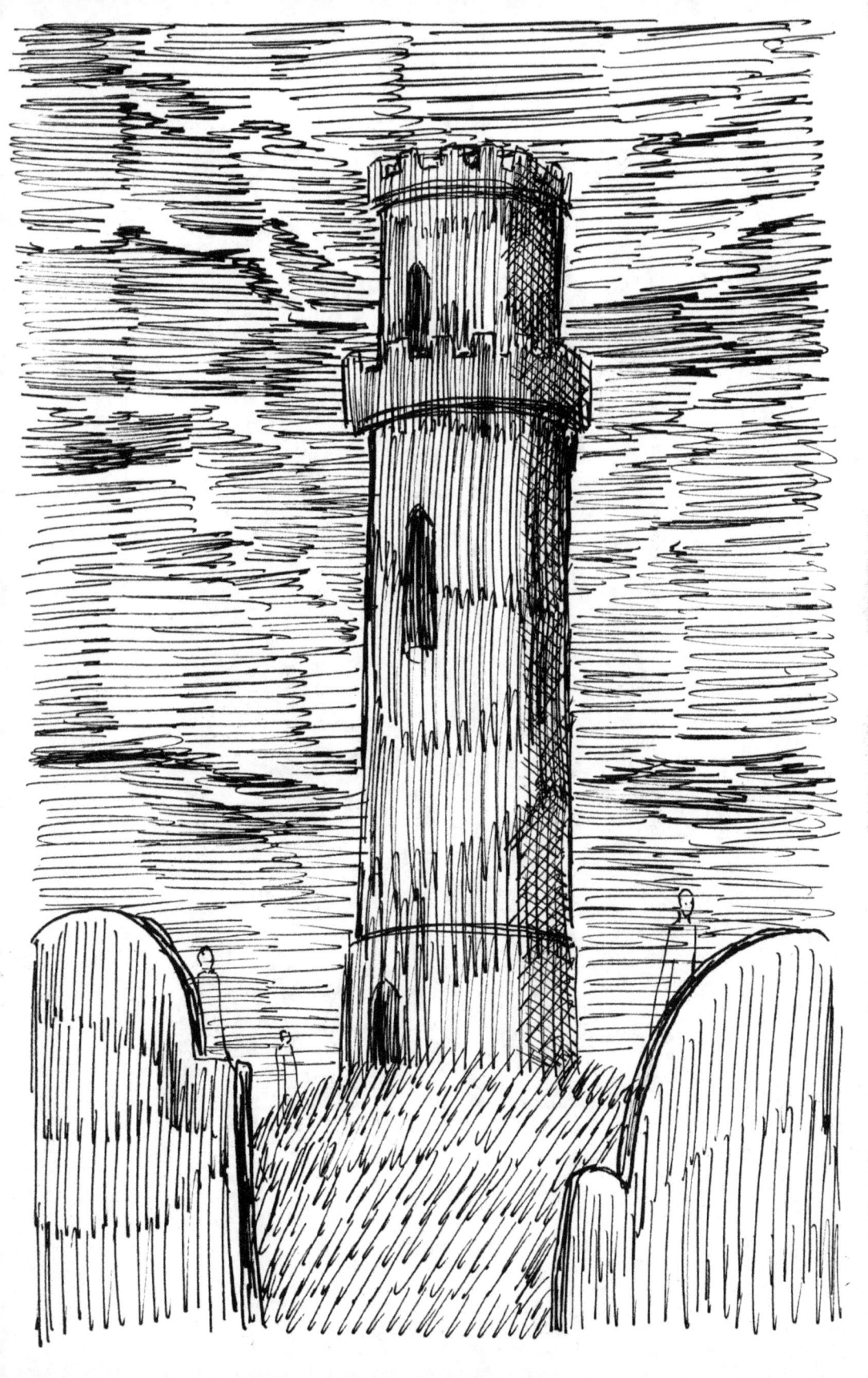

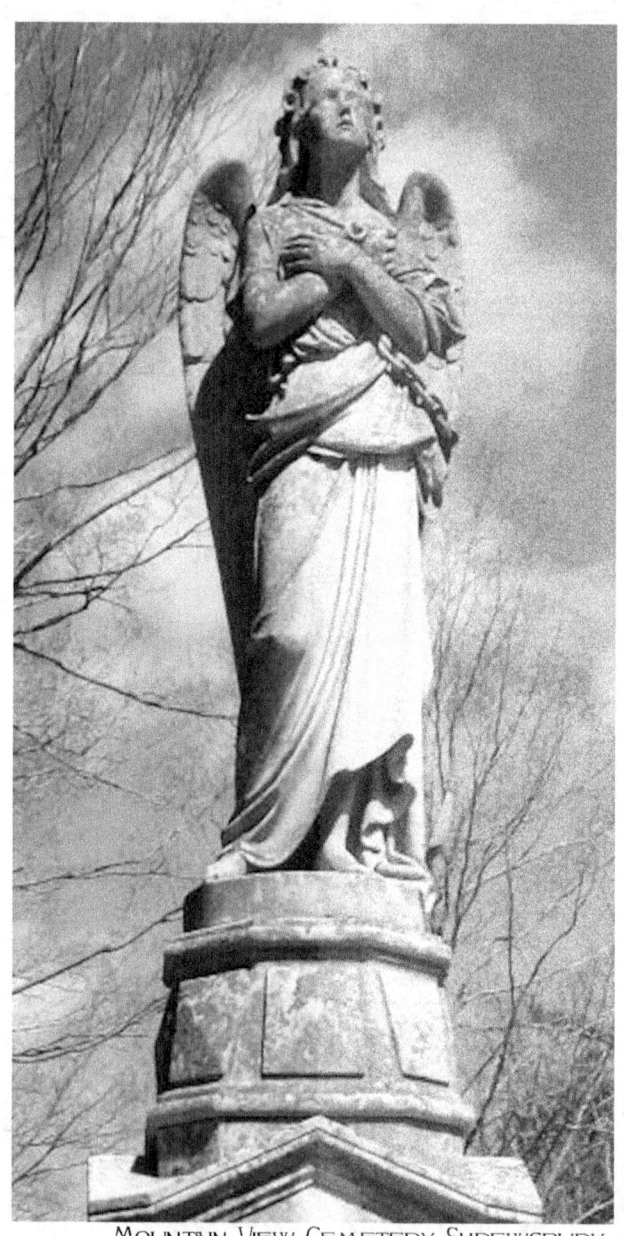
Mountain View Cemetery, Shrewsbury

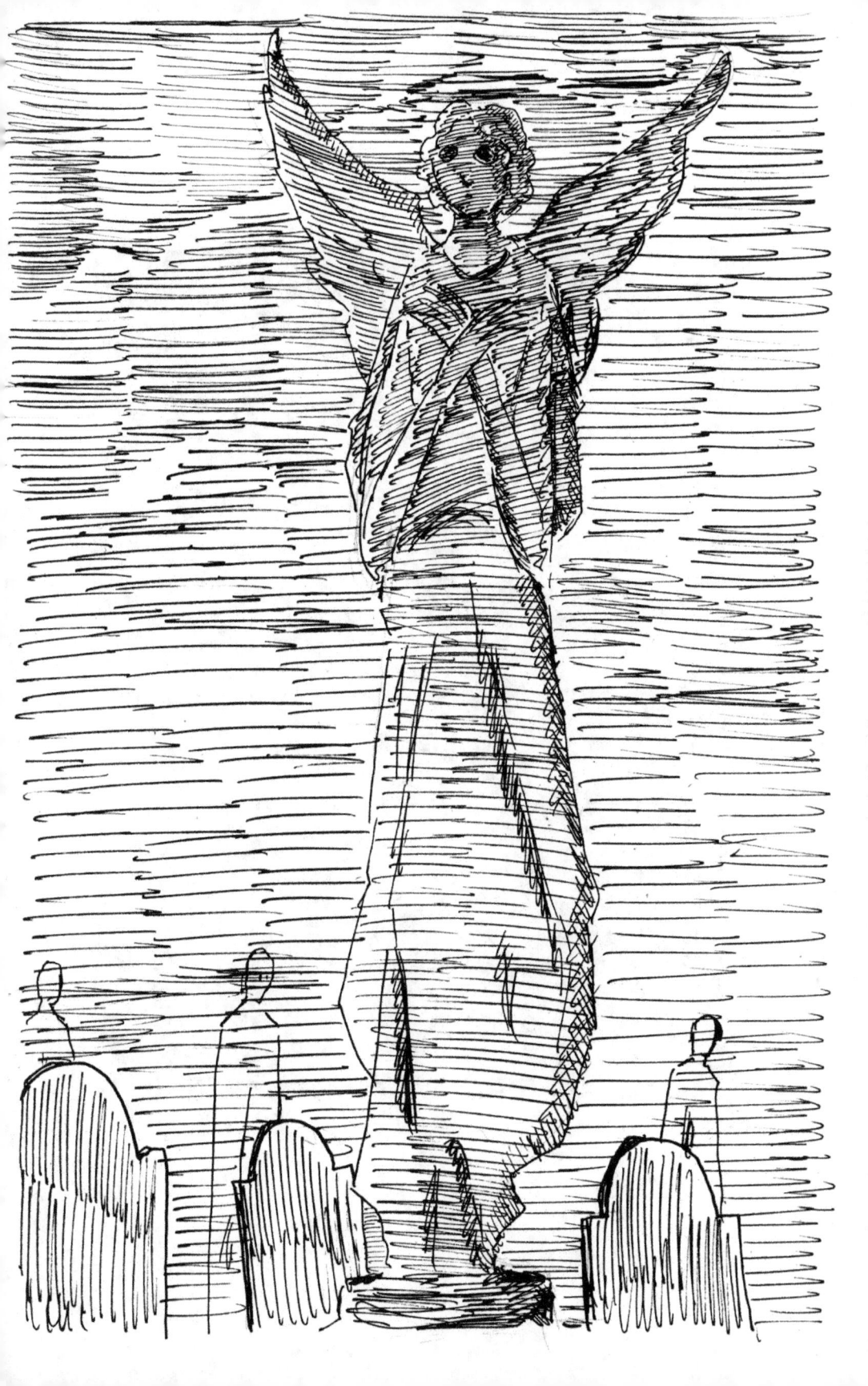

RURAL CEMETERY, WORCESTER

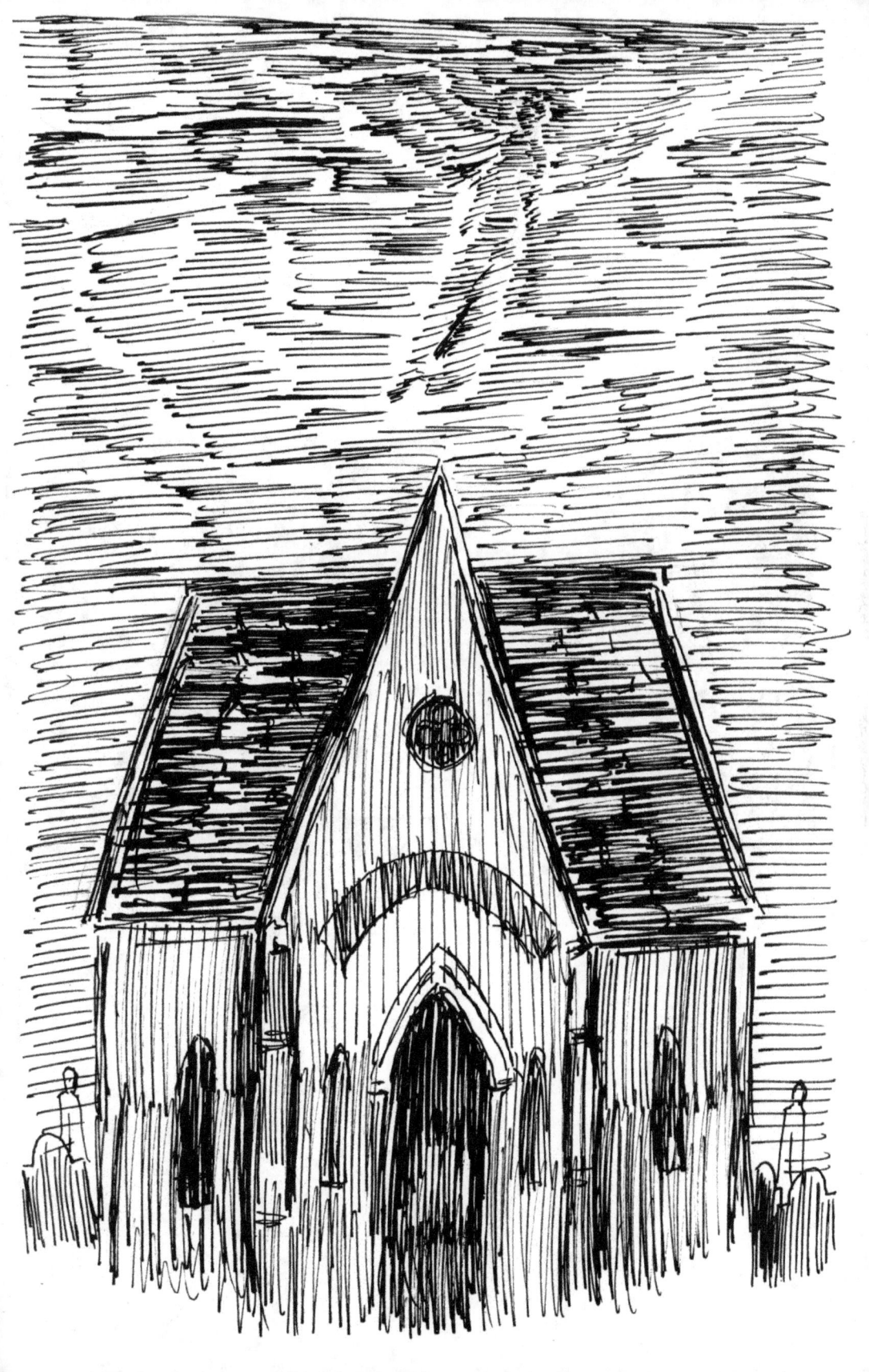

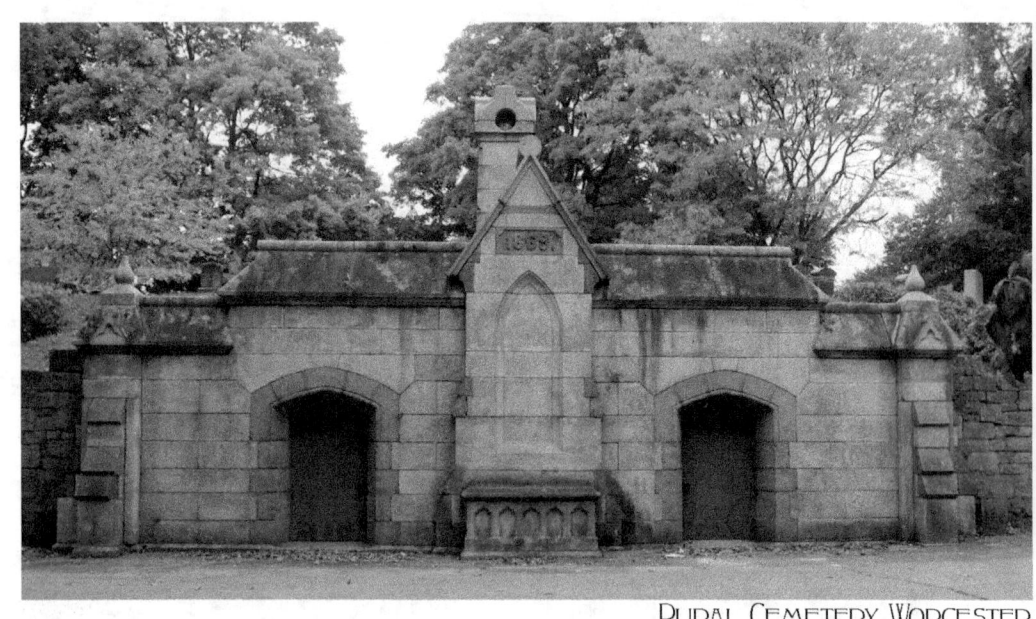
Rural Cemetery, Worcester

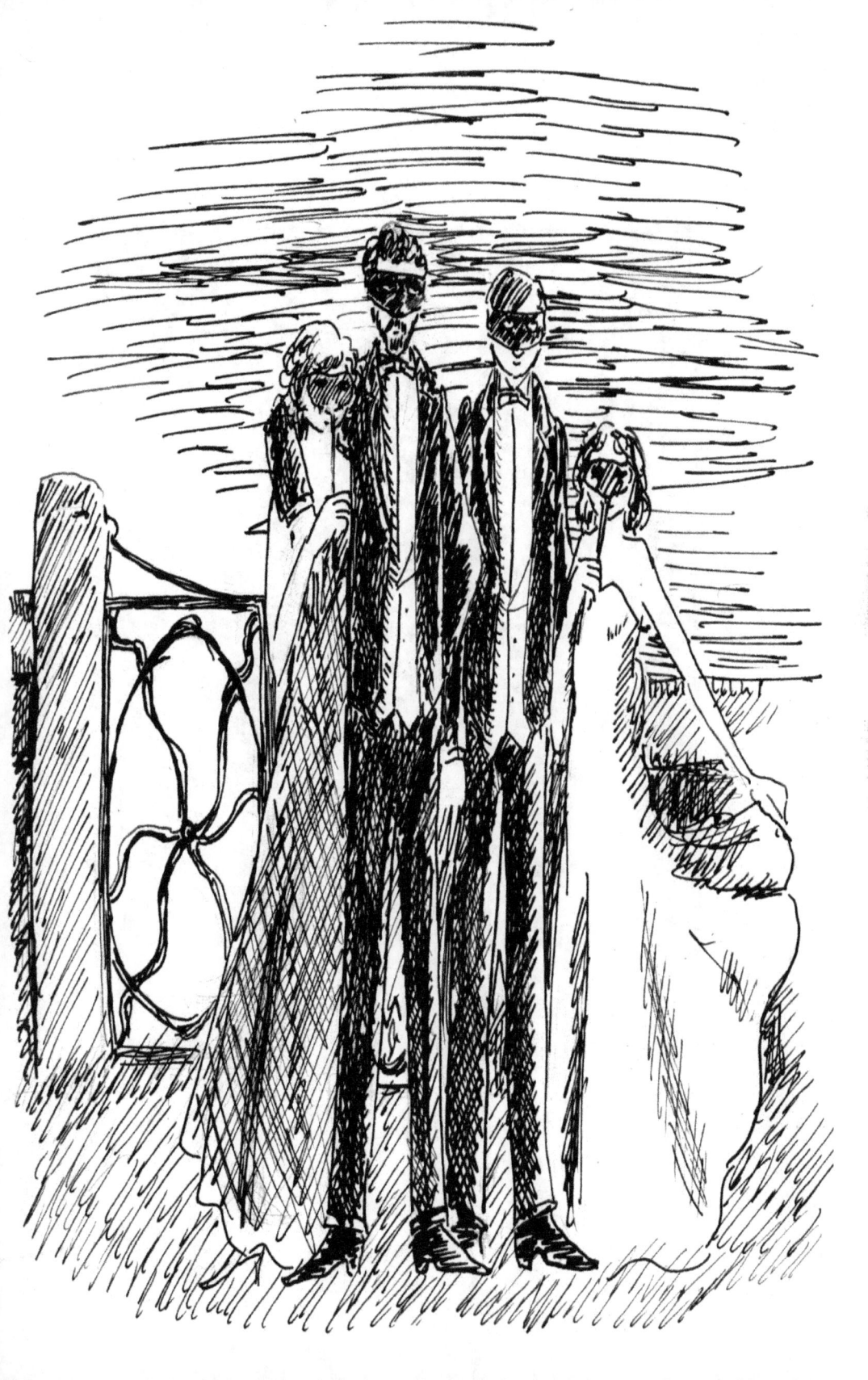

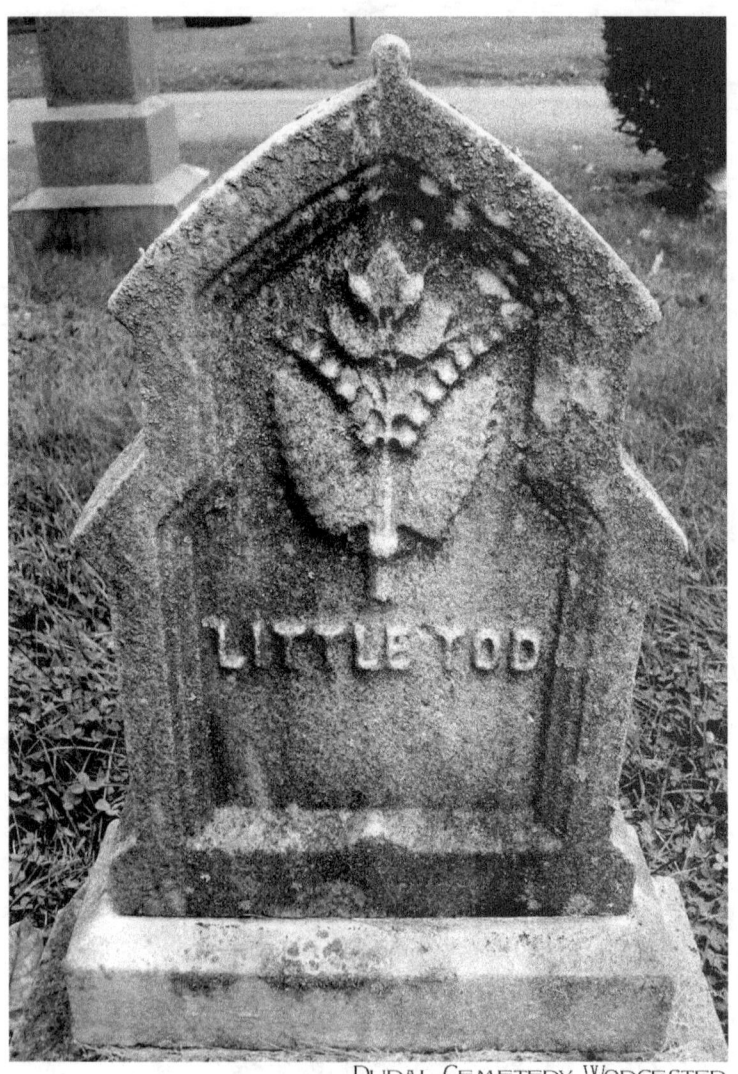

Rural Cemetery, Worcester

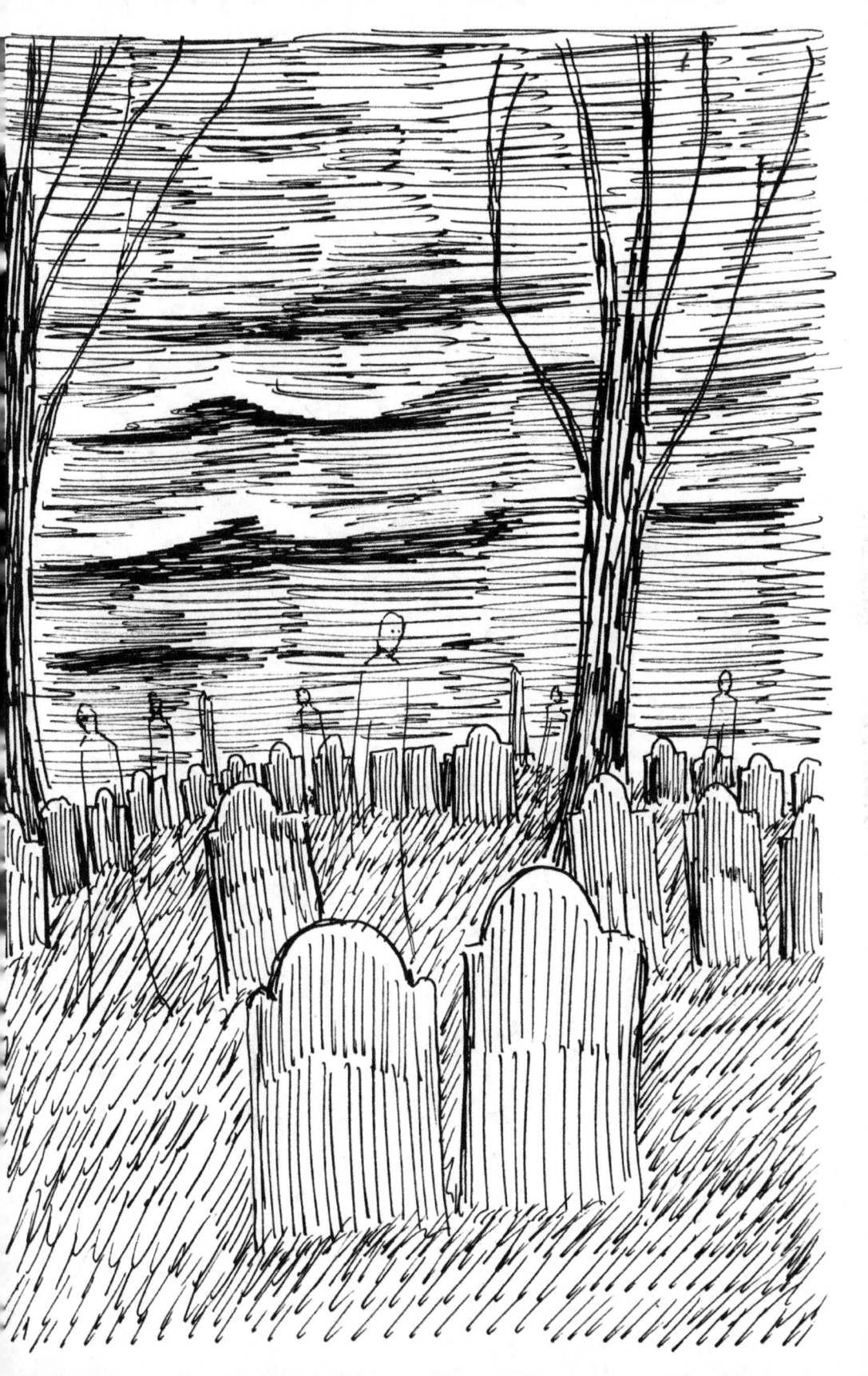

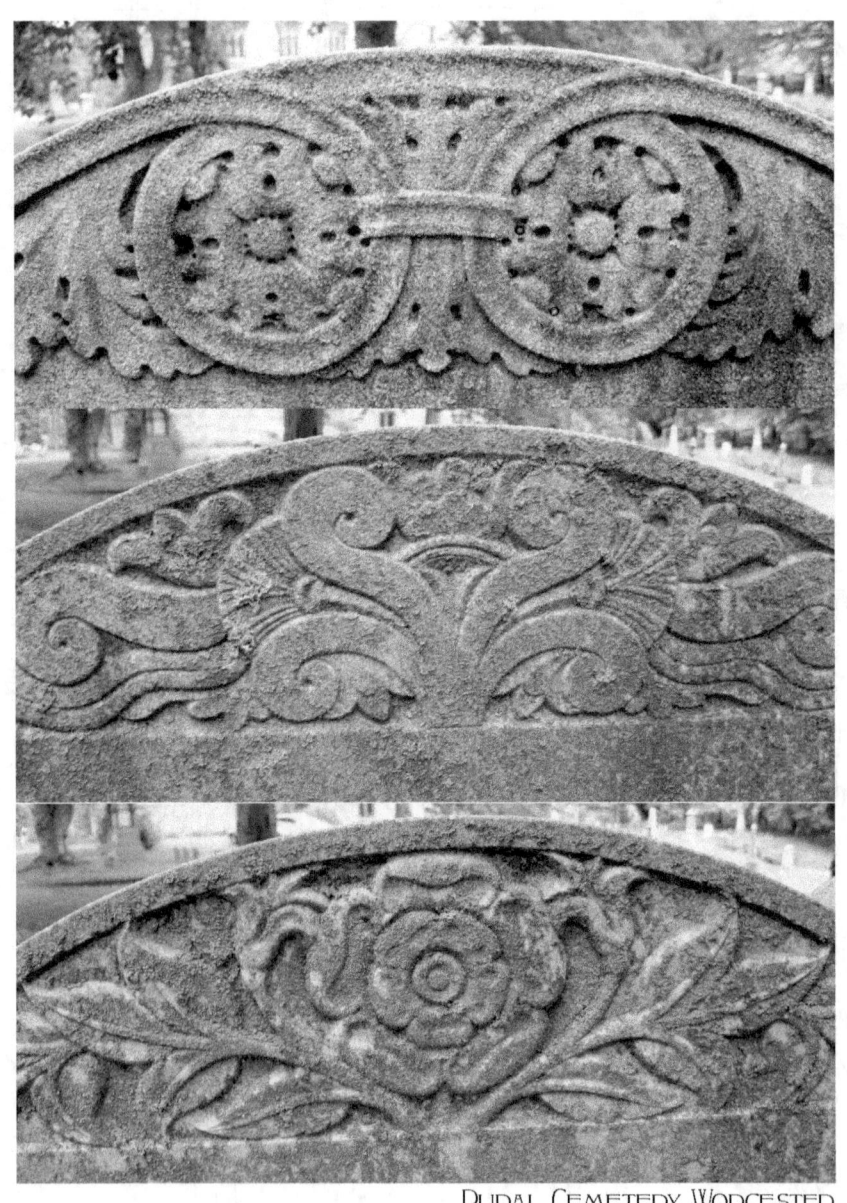

Rural Cemetery, Worcester

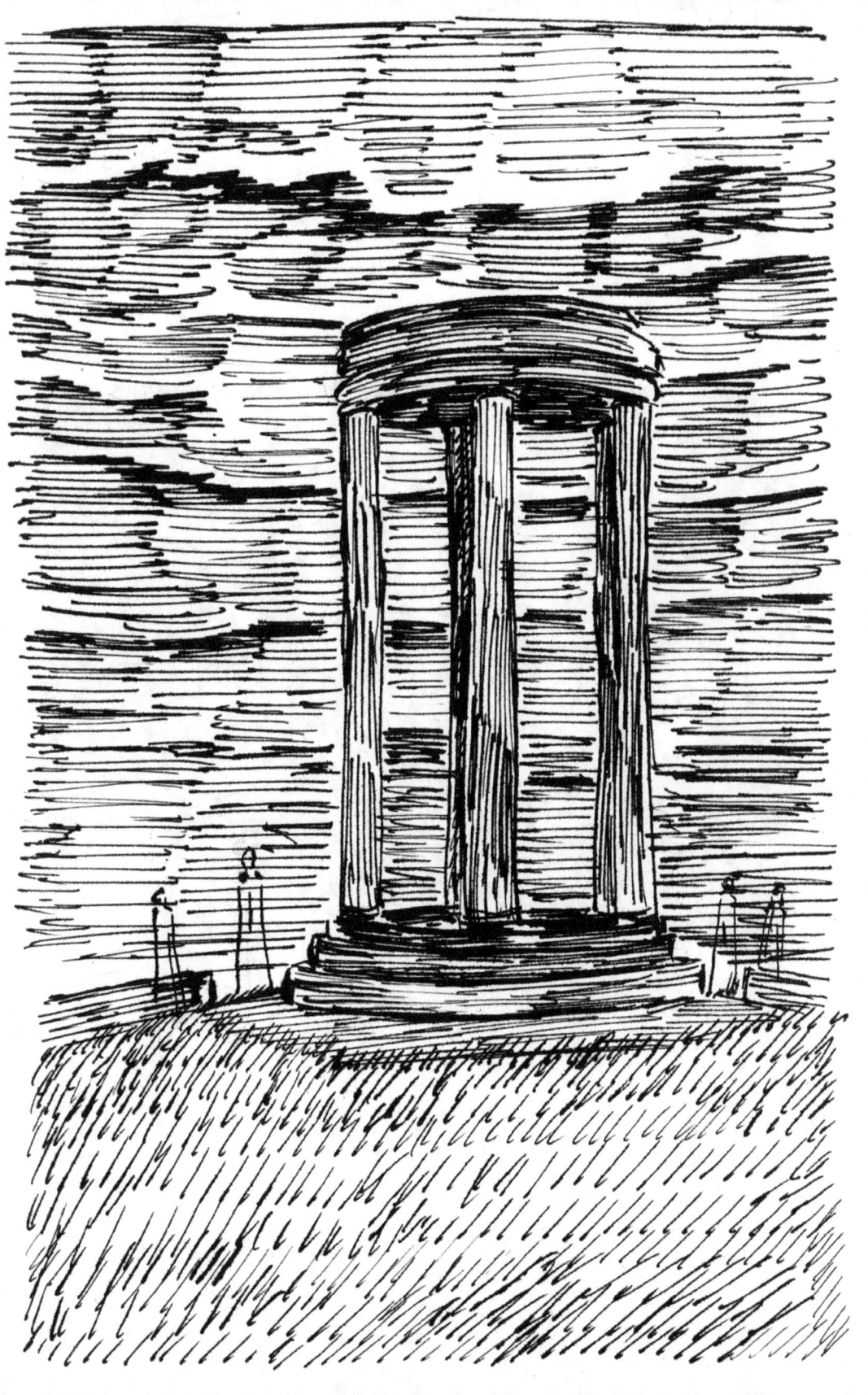

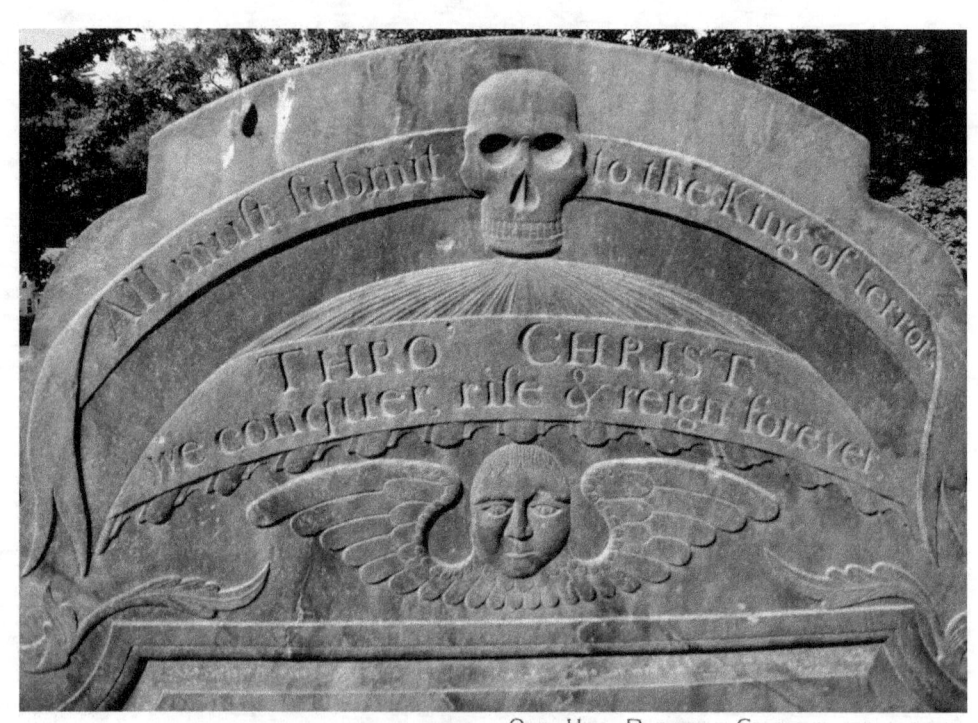

Old Hill Burying Ground, Concord

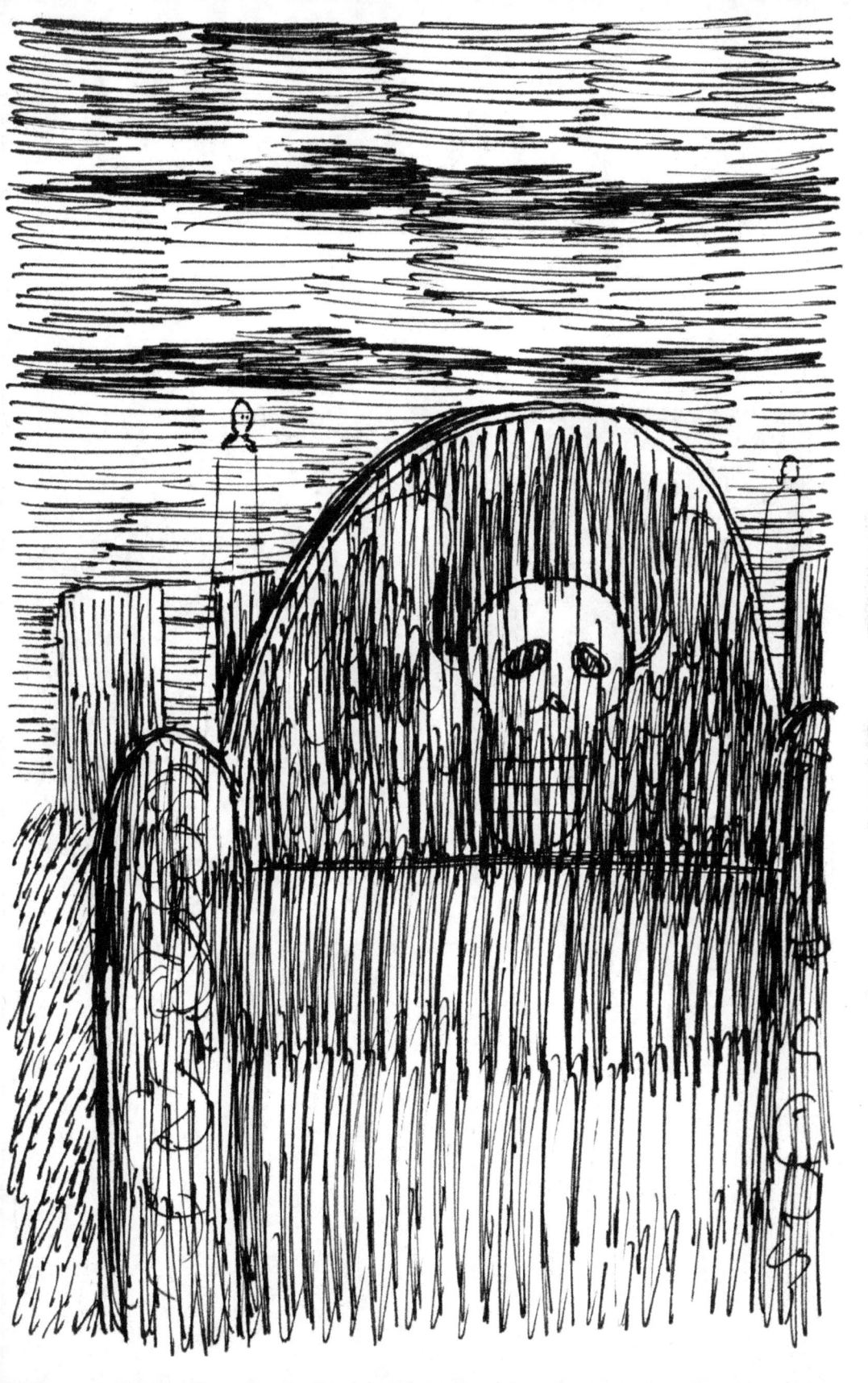

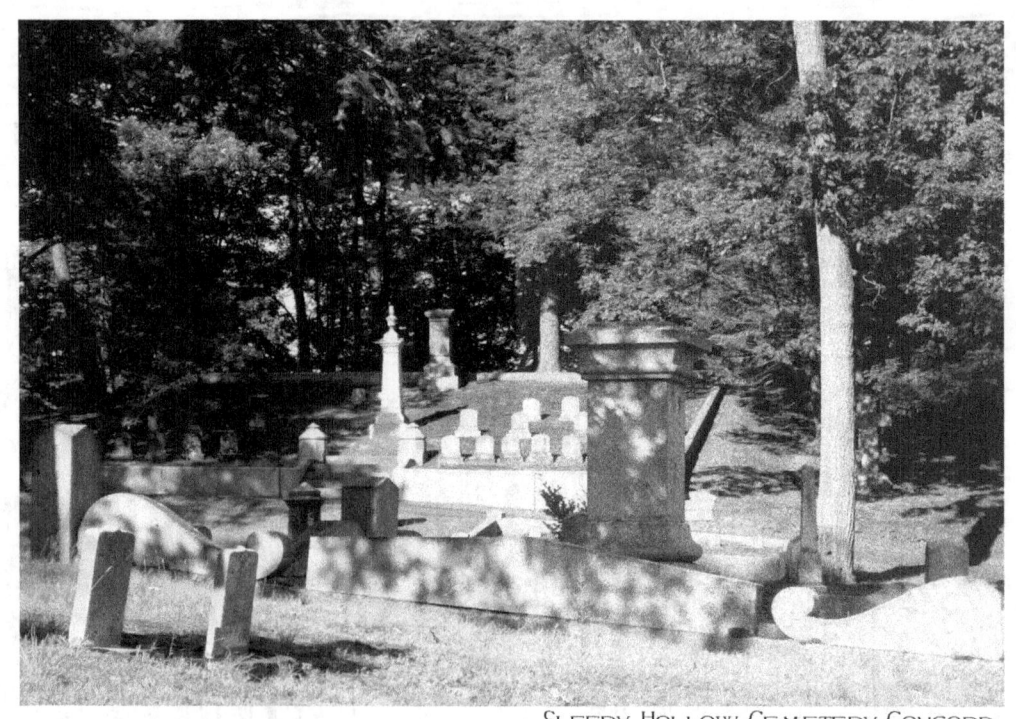

Sleepy Hollow Cemetery, Concord

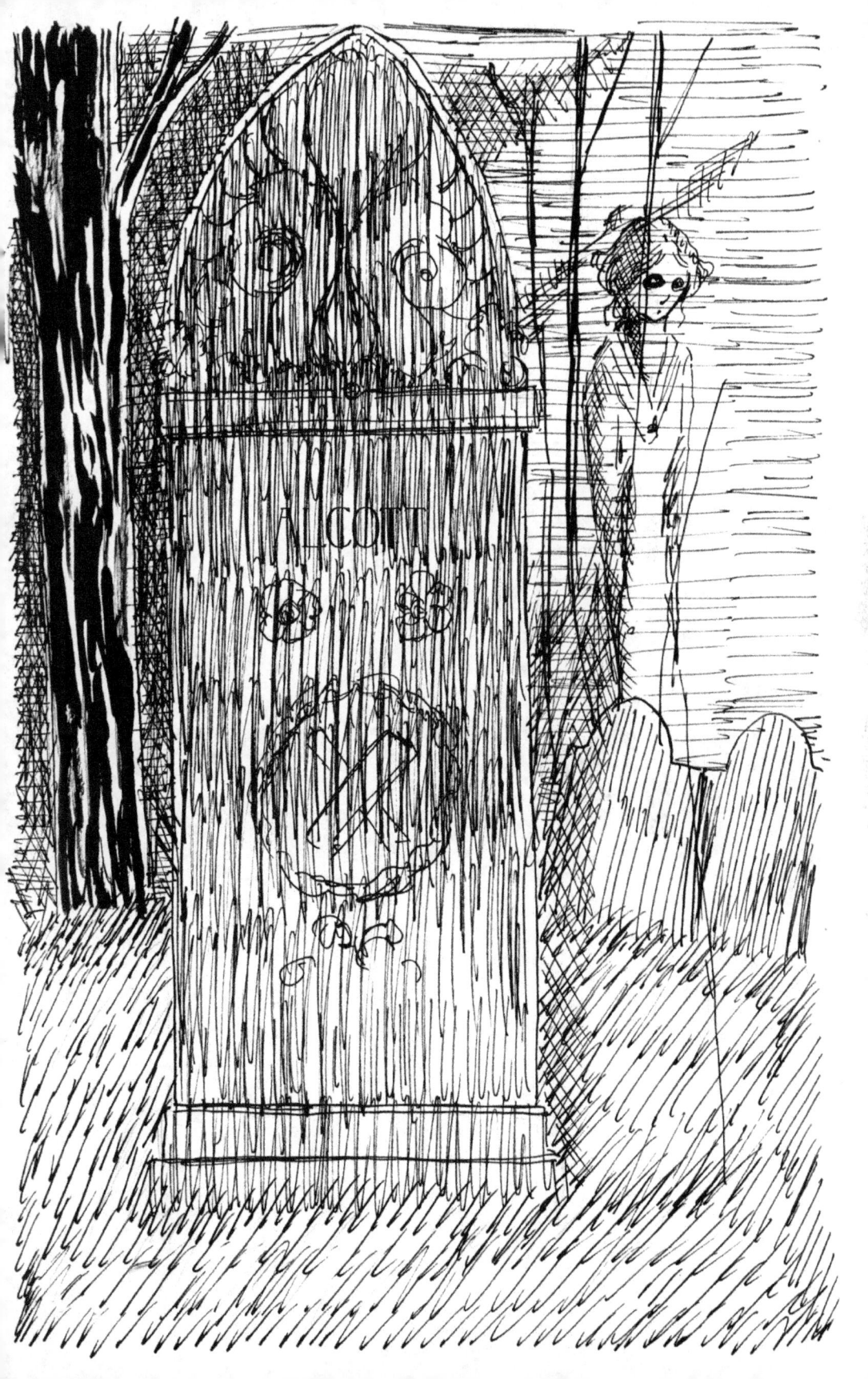

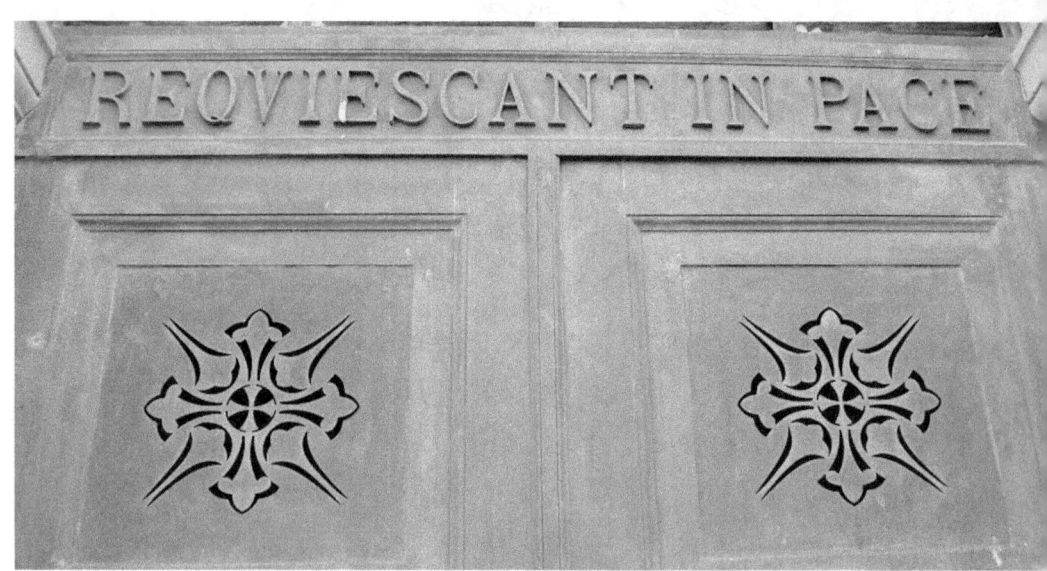

Bridge Street Cemetery, Northampton

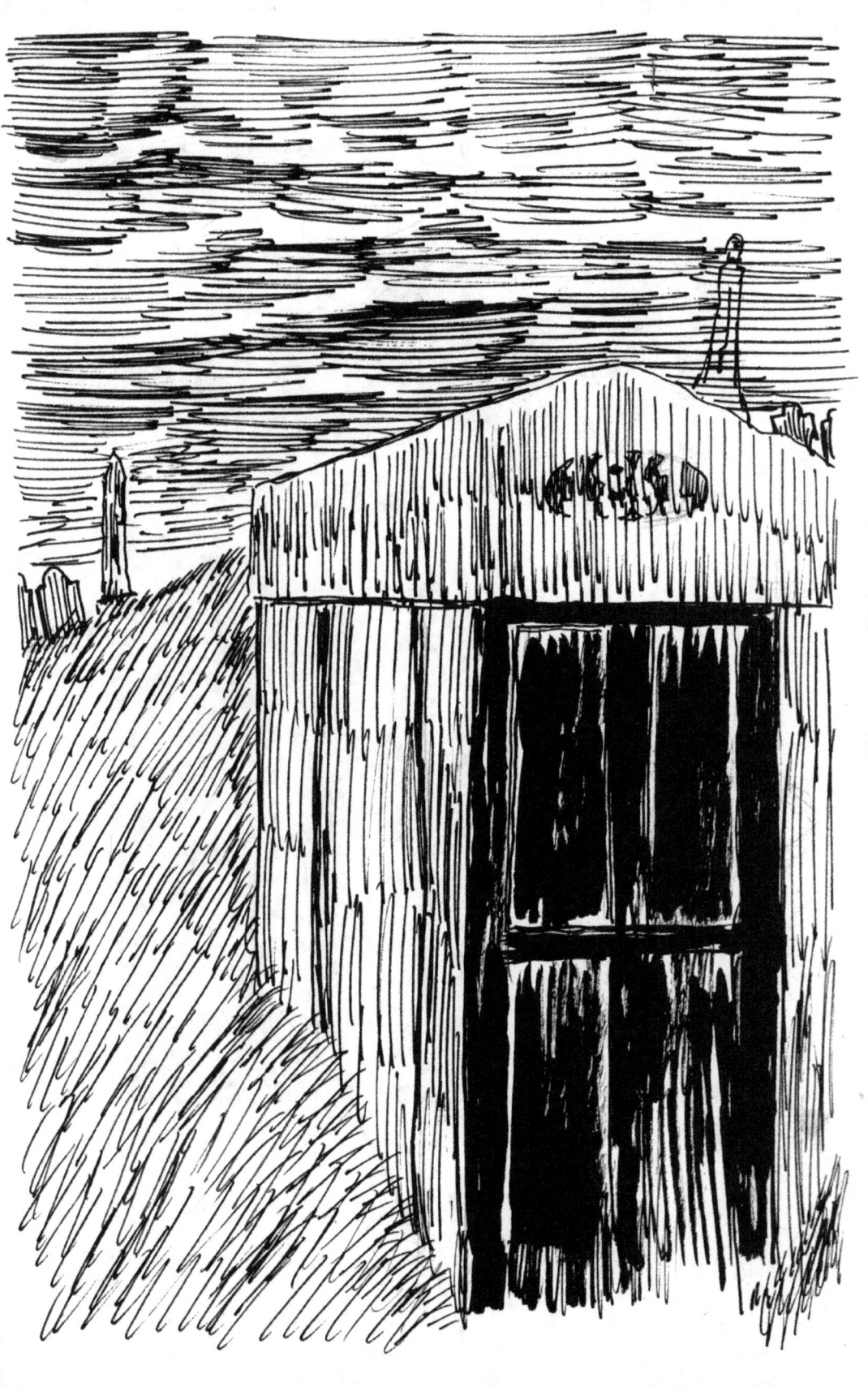

Rural Cemetery, Worcester

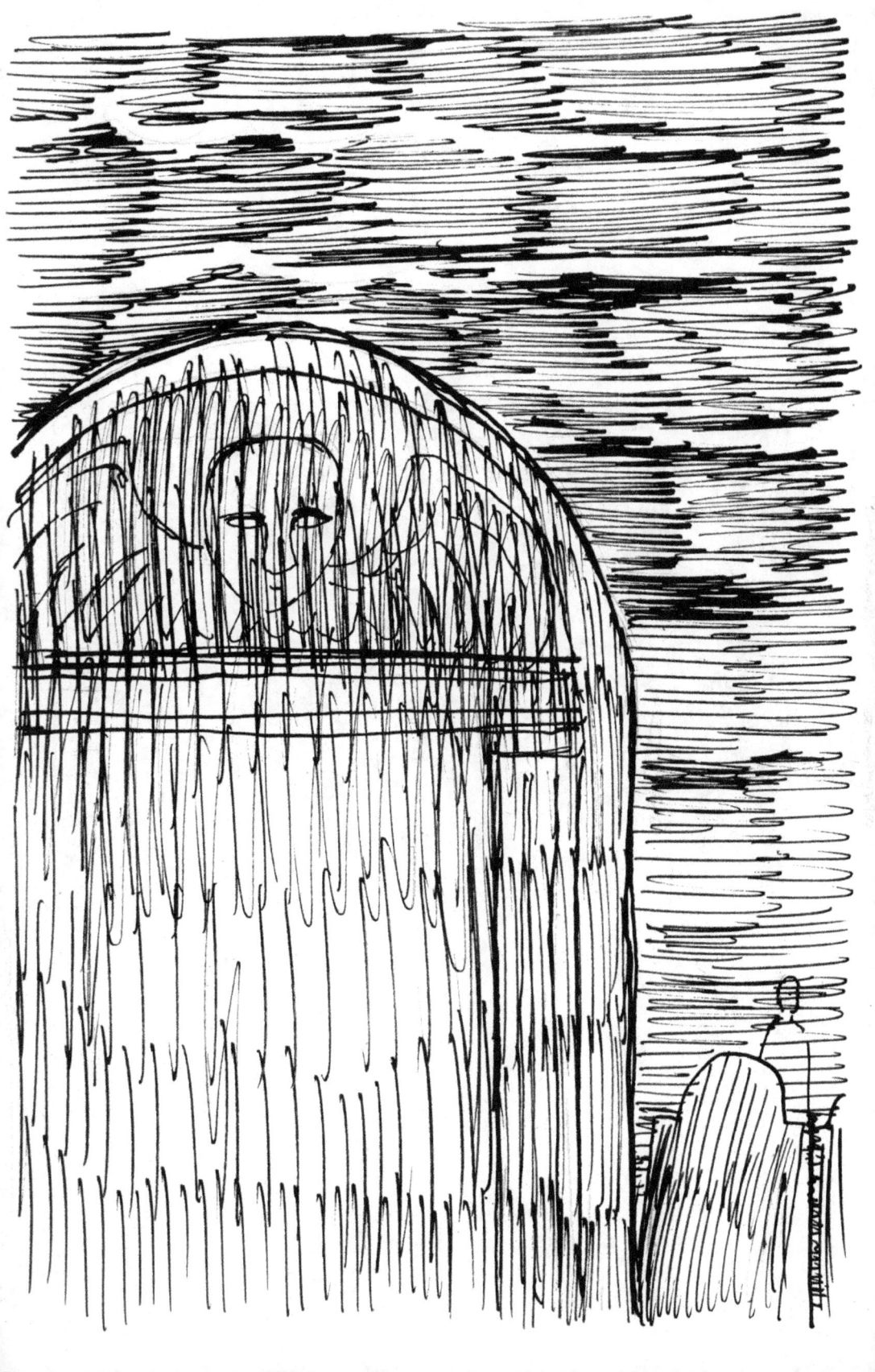

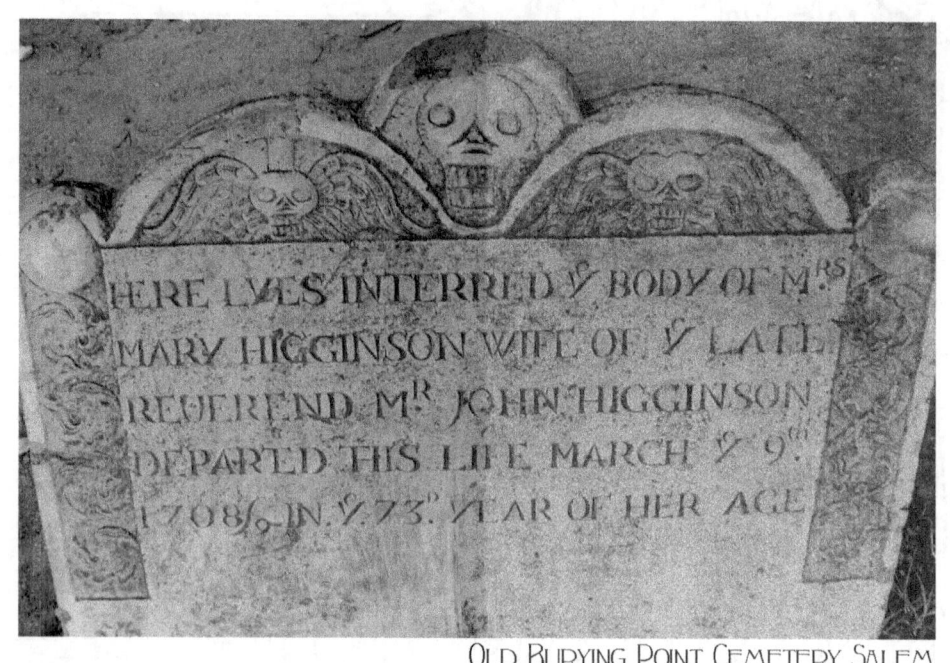

Old Burying Point Cemetery, Salem

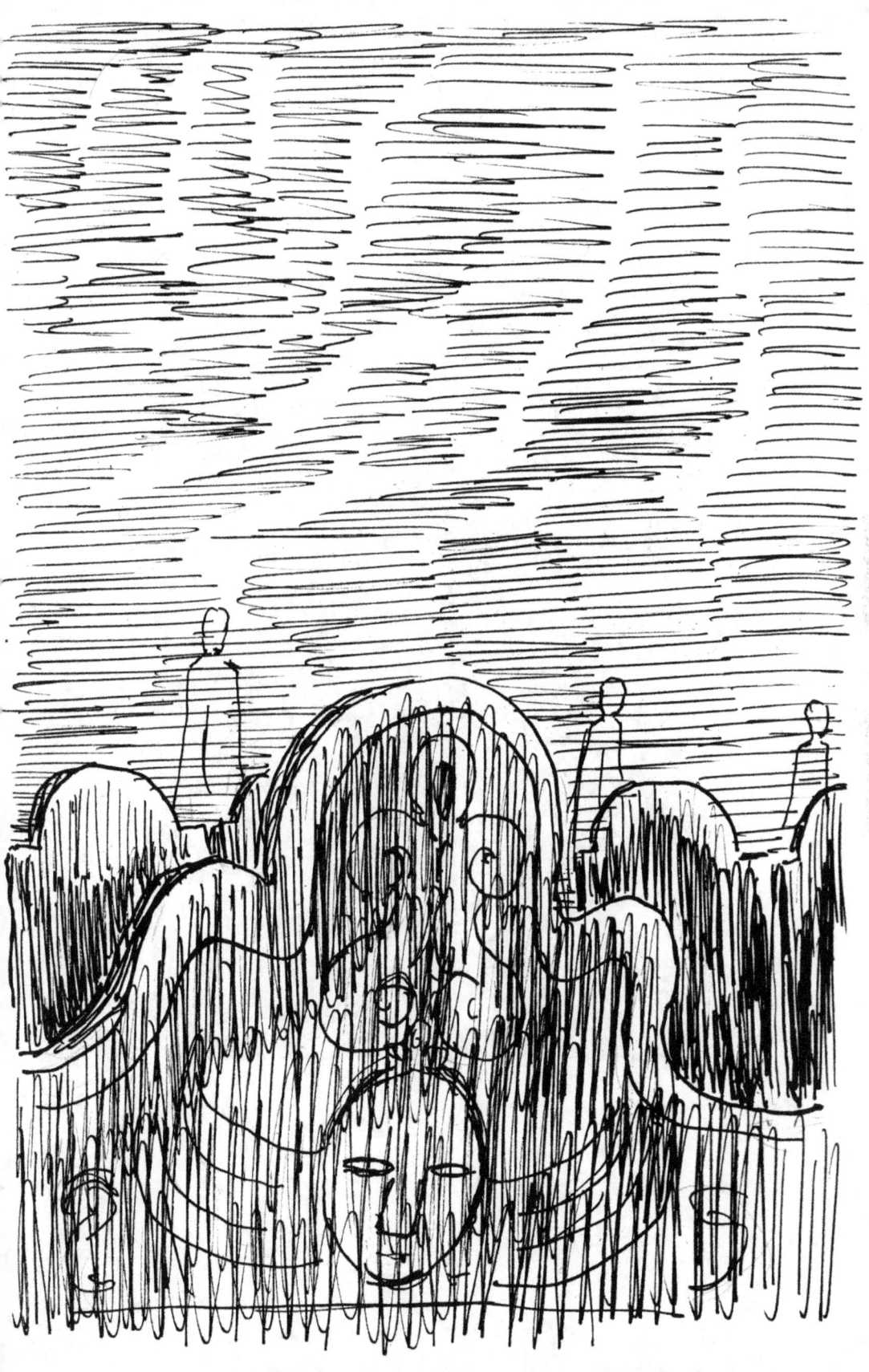

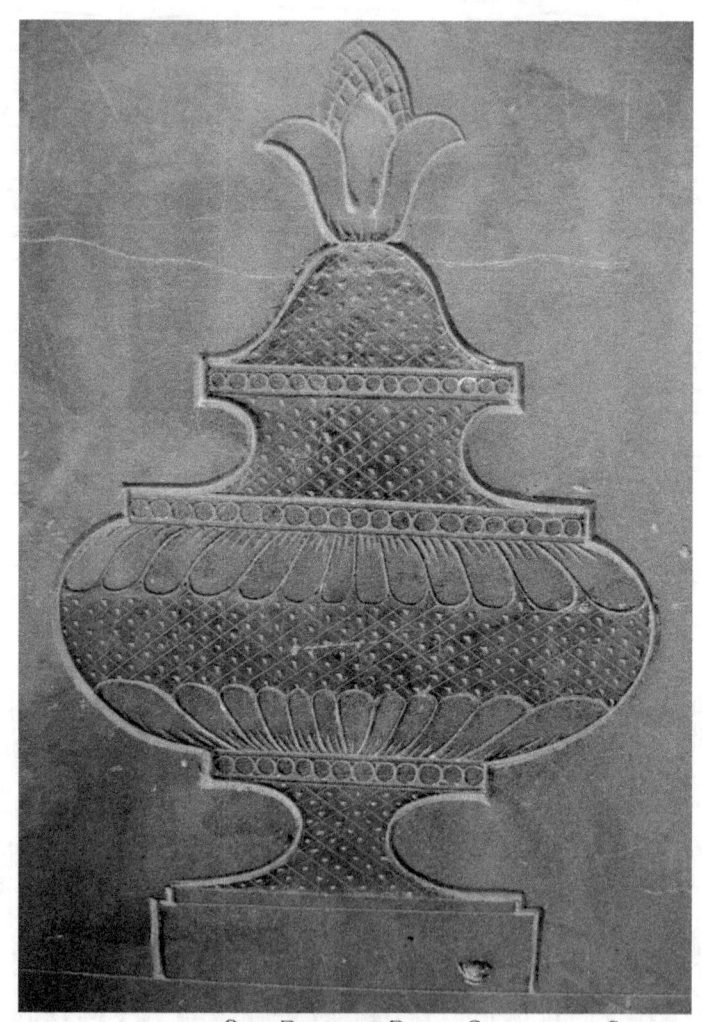

Old Burying Point Cemetery, Salem

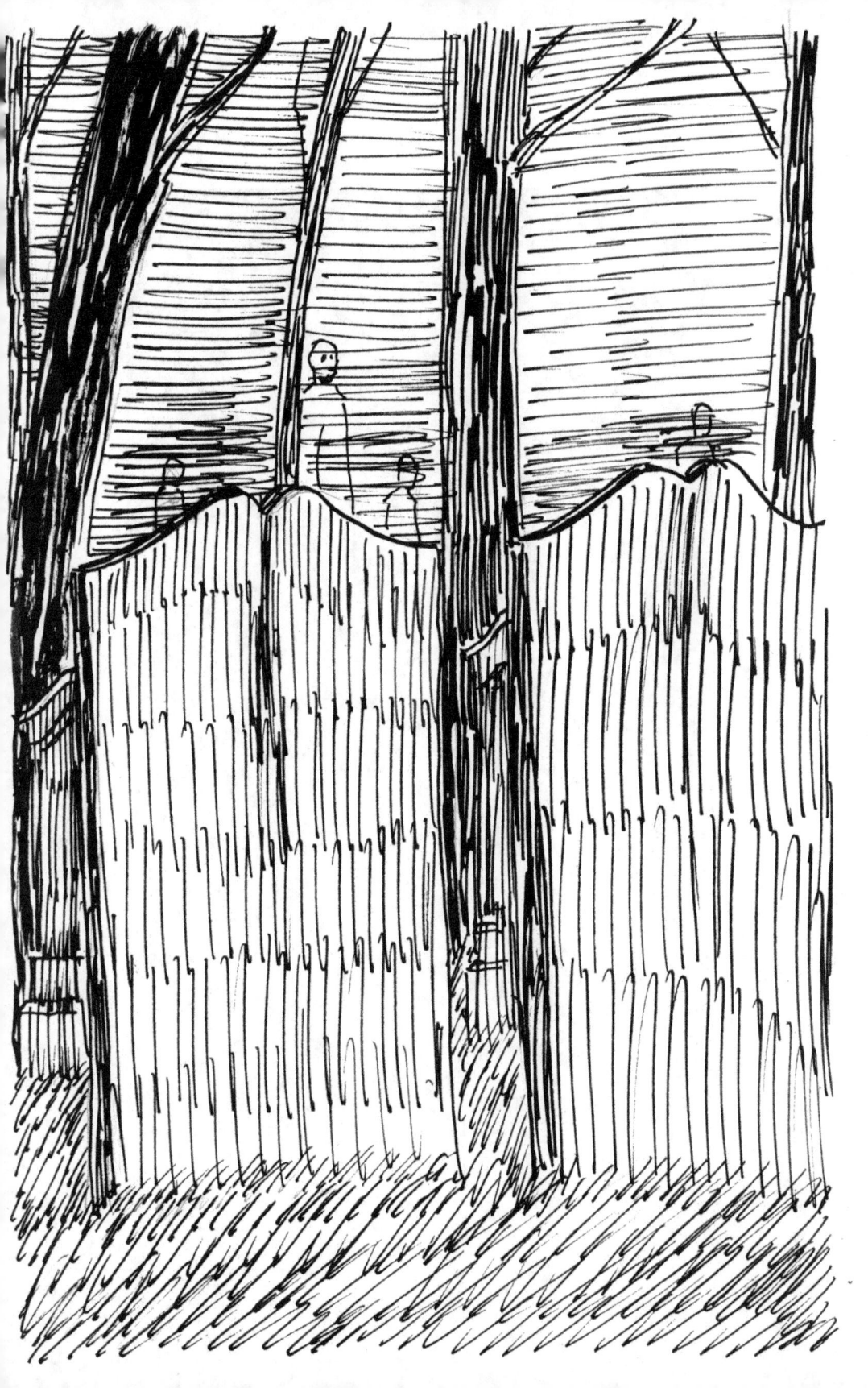

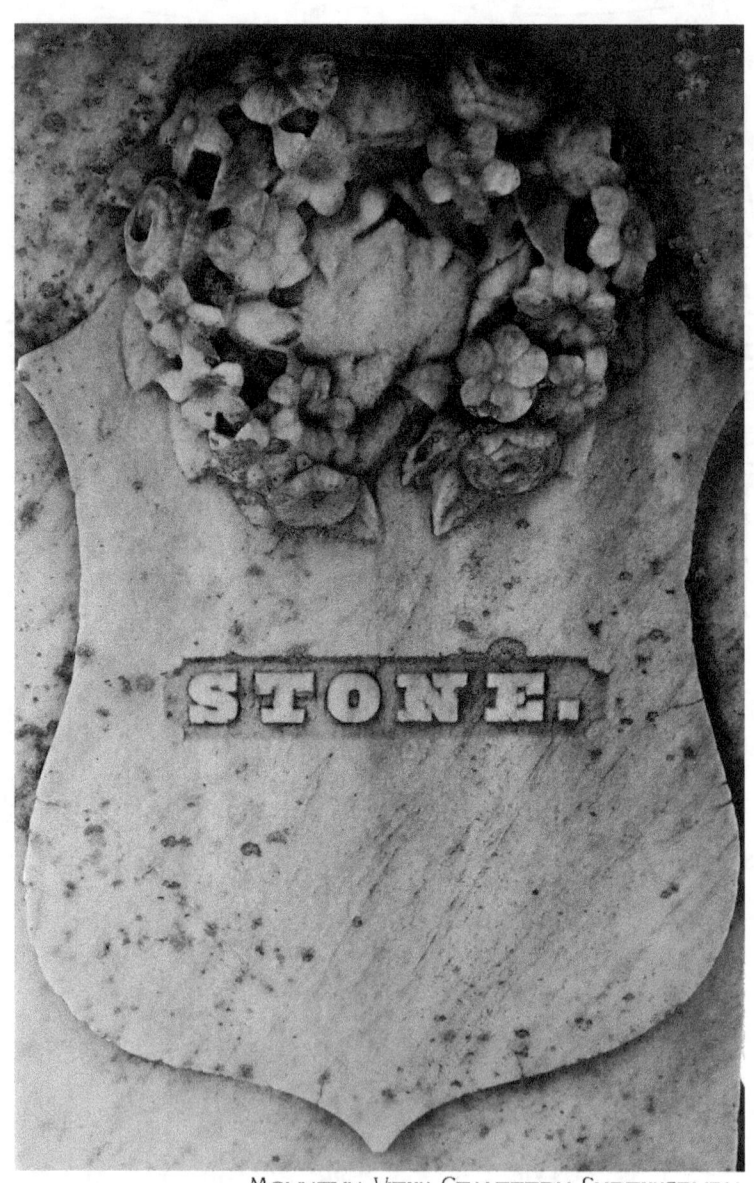

Mountain View Cemetery, Shrewsbury

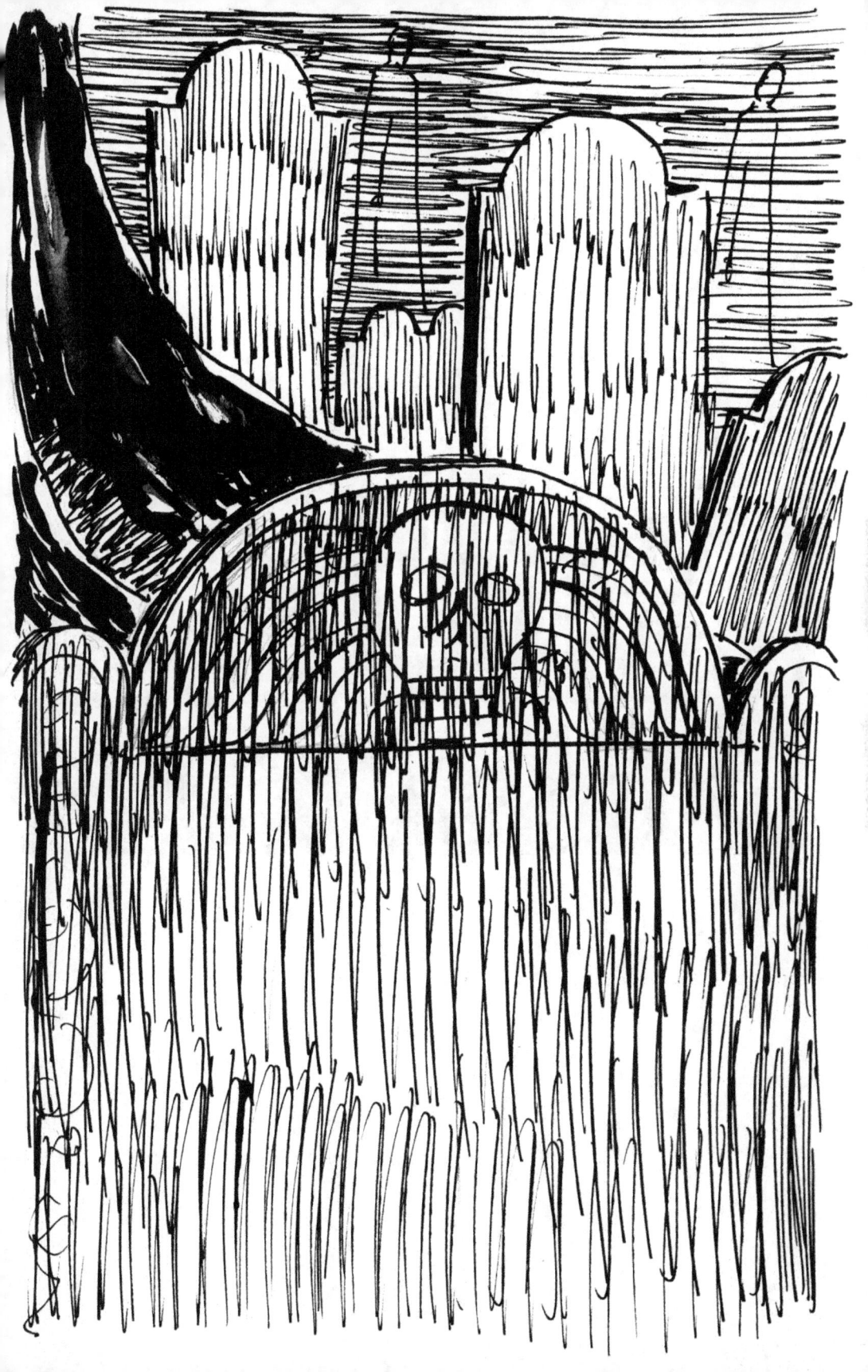

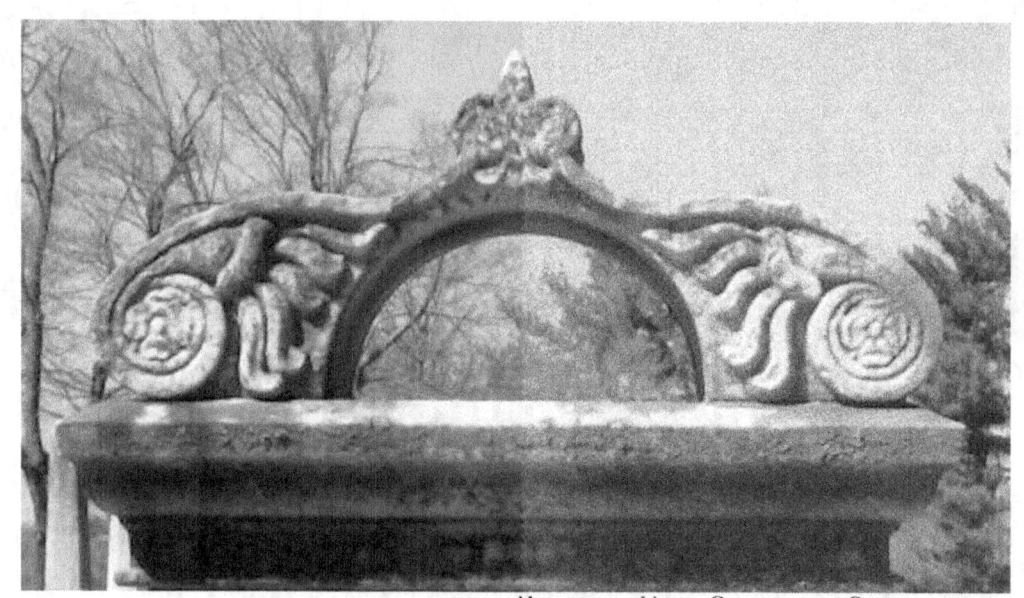

Mountain View Cemetery, Shrewsbury

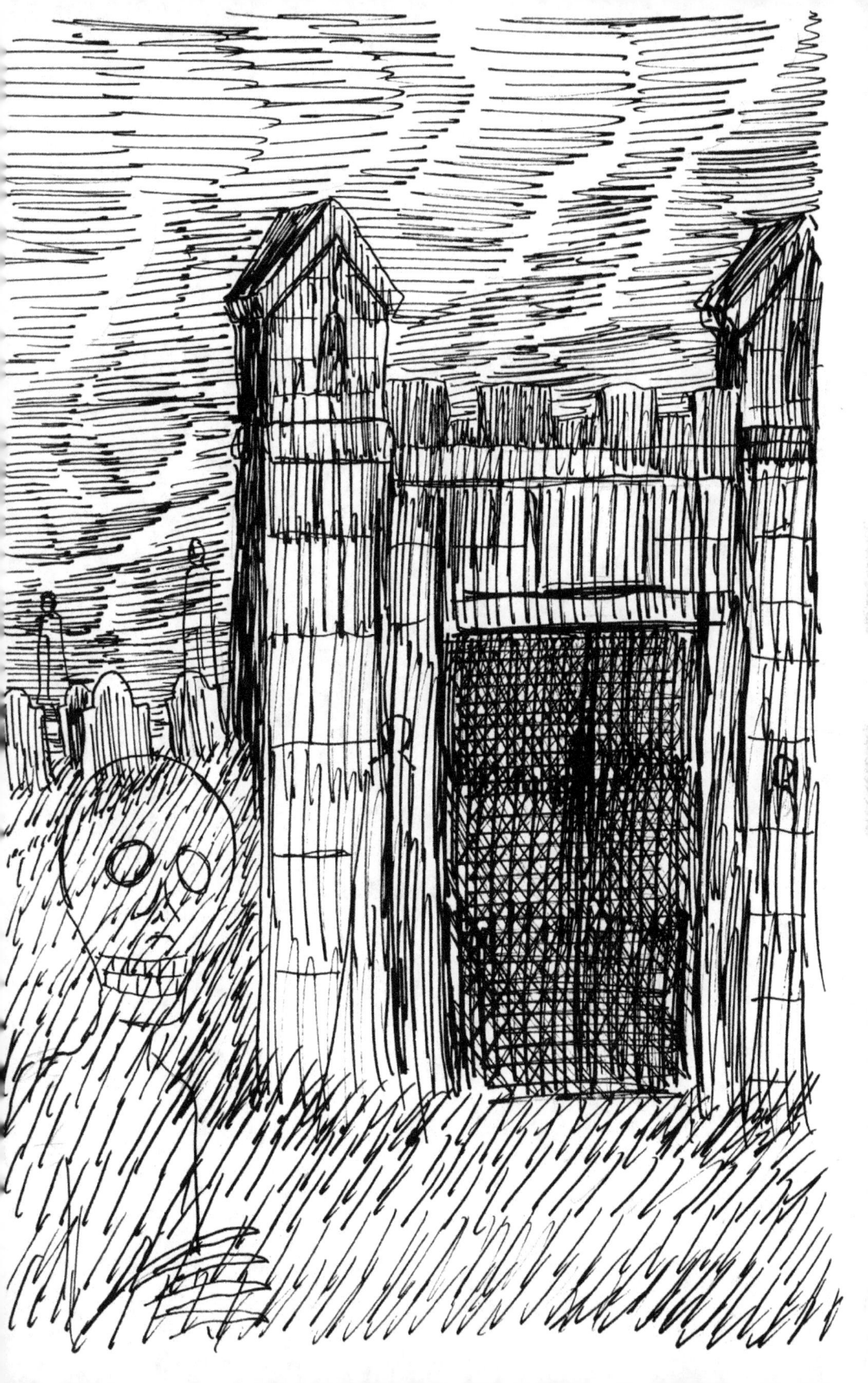

Mountain View Cemetery, Shrewsbury

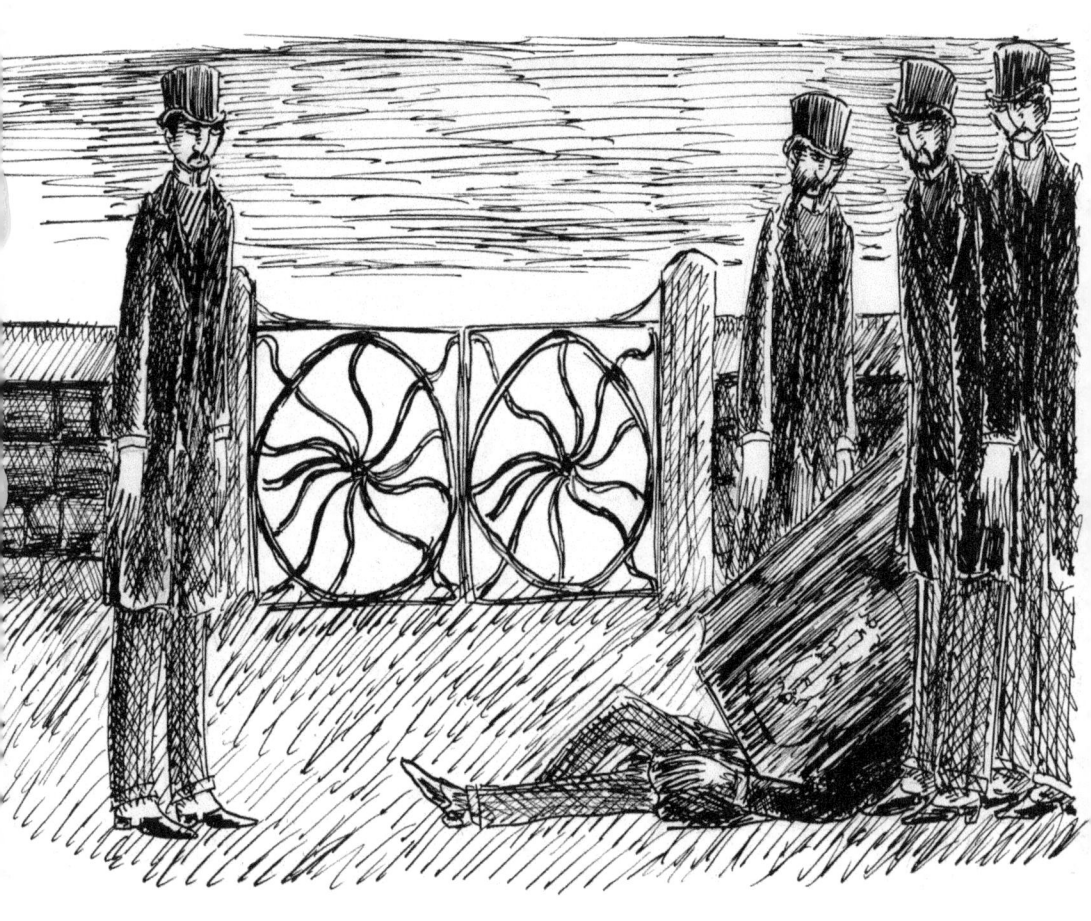

www.ingramcontent.com/pod-product-compliance
Lightning Source LLC
Chambersburg PA
CBHW061520180526
45171CB00001B/260